Various Subjects

WITH MIXED MED

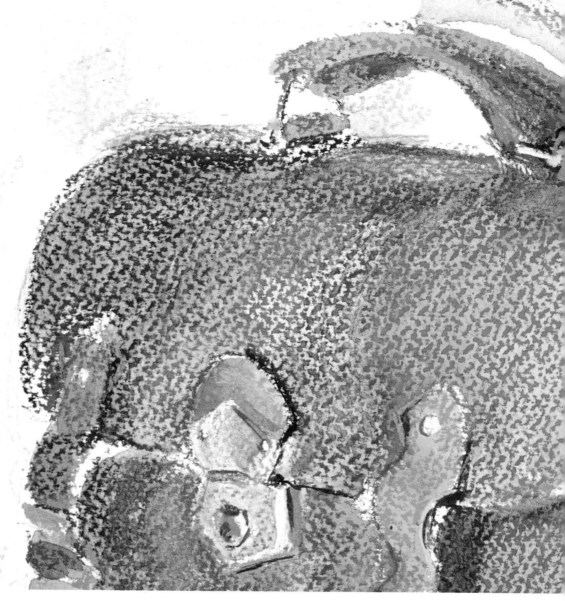

All inquiries should be addressed to:
Barron's Educational Series, Inc.
250 Wireless Boulevard
Hauppauge, New York 11788

Library of Congress Catalog Card No. 96-14716

International Standard Book No. 0-8120-9748-3

Library of Congress Cataloging-in-Publication Data

Braunstein, Mercedes.
 [Temas varios/tecnicas mixtas. English]
 Drawing and painting various subjects with mixed
media / Mercedes Braunstein.
 p. cm. — (Easy painting and drawing)
 ISBN 0-8120-9748-3
 1. Mixed media painting—Technique. I. Title.
 II. Series: Easy painting and drawing.
ND1505.B7313 1996
751.4—dc20 96-14716
 CIP

Printed in Spain
9 8 7 6 5 4 3 2 1

E A S Y
Painting & Drawing

WITH MIXED MEDIA

Various Subjects

BARRON'S

CONTENTS

*I*n the world of drawing and painting, there are certain basic universal guidelines. Regardless of the historical period in which a painting was created or the particular school the artist followed, these elements never change. For example, a painting's composition is ruled by the laws of human proportion and perspective.

There are other elements, however, like style, use of color, or the general concept of painting, that are the result of techniques used by a specific painter. These ingredients are highly personal, arising as they do from the individual genius of a particular artist; and they are neither easily categorized, nor are they chained to dogmatic rules. Such highly idiosyncratic elements characterize the painting of a particular period as well as its painter. This interplay between the universal and the particular makes painting an endlessly imaginative and creative field of human endeavor.

This book has been written especially to release those personal artistic elements so that initiative and experimentation go hand in hand with imagination and freedom of expression. There is, of course, a certain amount of risk involved in combining different media, but, on the other hand, the resulting creation can be enormously satisfying. Certain textures, creative effects, or visual impacts are only possible by fusing various media. For this reason, it was essential to include this title in this series. Space constraints made it impossible to include all those topics we would have liked to present, but we believe that those subjects we have included will provide readers with a good introduction to the subject mattter.

This volume offers readers two types of exercises. One group will introduce the most basic tech-

niques, while the other will present techniques that are more modern and aimed to achieve unique effects. Be aware that the techniques and media we are introducing are not meant to create a narrow interest in abstract or experimental painting. We have included subjects—animals, flowers, still life, landscapes, and the human figure—that cut across time periods and have a universal appeal.

We hope that the exercises contained herein will help you appreciate the remarkable artistic effects that can be achieved by mixing media, and that you will be inspired by the dynamic interplay, experimentation, imagination, and energy shown in these pages. If a person's spirit, feelings, sensations, perceptions of reality, and ways of communicating those perceptions can be combined, then the techniques artists use to create their messages can also be combined. Take heart friend; if you follow this well-trodden path, you will discover personal resources that you never believed were there.

Jordi Vigué

MIXED MEDIA

It is possible to draw and paint using any medium. It all depends on the theme you have chosen and what you want to say; for instance, some media are more suitable than others for creating either a subtle effect or a strong one.

Generally, the reason why an artist is prompted to work with mixed media at the same time is to overcome the limitations of a single medium. It is also possible that a combination of media enables the artist to achieve the desired result more quickly, or more easily. A picture executed in a variety of media that are well used may be considerably enriched.

Restlessness and a desire to explore often form part of the creative personality. Therefore artists may "discover" a fitting combination of media by chance. I write "discover" in quotes because today there is little left to discover. I believe

that, in general, innovation consists of the personal way in which an artist uses media.

A book dealing with mixed media is a captivating introduction into a world without boundaries. In addition, today there is a wide range of new products available that enable the artist to obtain numerous different and original results. It is interesting to become acquainted with them. Acrylic modeling paste, (an acrylic emulsion, containing powdered marble, which polymerizes) for instance, facilitates impastos, and has various applications in sculpture.

This modeling paste can be used to create impastos before you begin to paint in oils. It can also be colored with pastels or with acrylic paints. See the example below of modeling paste colored with pastels and note its texture (A). Here is a world to explore.

A

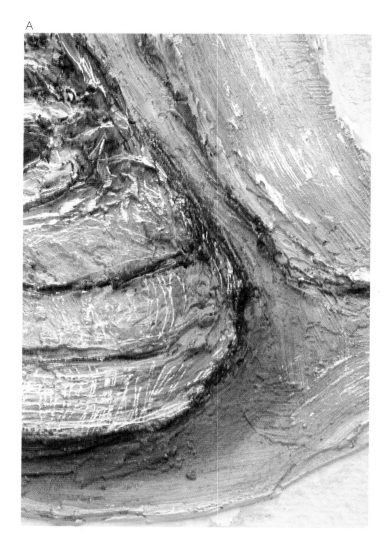

B

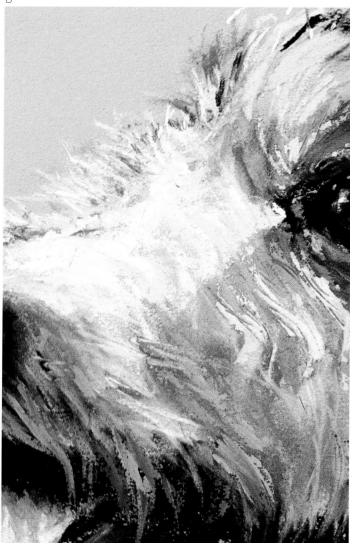

Many artists (Degas, for instance) experimented by combining media, in their search of ways of better preserving their paintings. If you paint on a pastel support with gouache, you can work with impastos, and the work will become more resistant (B). The use of oils and acrylics in the same painting, for example offers the properties of both: the brightness of oil and the fast-drying quality of acrylic (C). Other combined techniques continue to be applicable thanks to their delicacy and usefulness. A case in point is the use of color in powder form (sanguine Conté crayons, pastels, and pigments) (D).

There are certain mixed media that require a very specific painting surface. To take advantage of the masking characteristics of wax with respect to watercolor, with a pointillé result, you need a sheet of rough-texture watercolor paper (E).

Consider two factors when choosing a painting surface for combining two media: It has to be appropriate for both media and should enable the artist to create the desired effect. Also familiarize yourself with the properties of each medium. Practicing with wax crayons and pastels, you will learn how to produce the effect of impastos and create textures with the aid of a cutter, or palette knife (F).

C

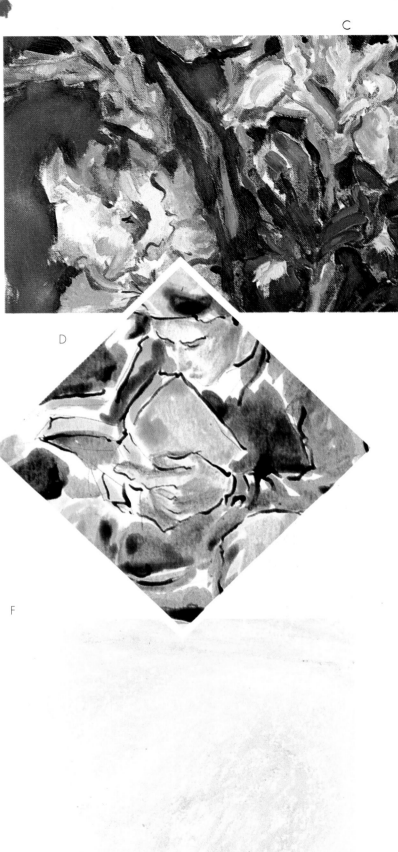

D

E

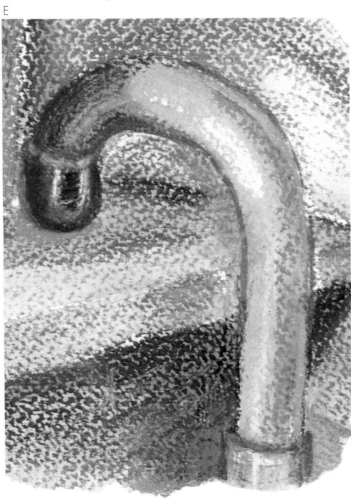

F

ACRYLICS AND OILS

A B

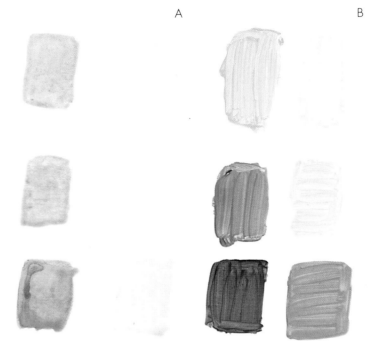

Acrylic paint has certain characteristics that differ from those of oil paints. Both media can be combined in a single painting.

I use acrylic paints in tubes that I dilute with water on a palette. I normally choose acrylic paints with a matte finish.

Since acrylic paints dry quickly, they can be used in pictures that have to be painted in a single session (such as flowers, that wither very quickly) and that require a lot of detail. Acrylic paint lends the work a durable finish because it dries hard and, once dry, is resistant to light and water. Naturally, one can paint an entire work in acrylics, but there is one effect that is more difficult to obtain with acrylic than with oil—that of atmosphere (the way in which the intervening space between two planes is depicted). Let's take a closer look at this.

Since oil paints contain oil, they adhere to the canvas in a special way. Transparent effects (when an underlying layer can be seen through one applied on top) that are painted with oils have a special luminous, oily finish that is difficult to describe. You will see this later on. Oil paints enable the artist to achieve an intermediate atmospheric effect that may enrich a painting. Bear in mind that it is possible to leave areas of the white canvas unpainted, a point we will examine more closely later on. One of the negative aspects of oil paints is that they dry much more slowly than acrylic.

With four acrylic colors (white, yellow, red, and blue) we can mix all the colors we need. The mixtures are prepared with a brush, diluting the paint with water.

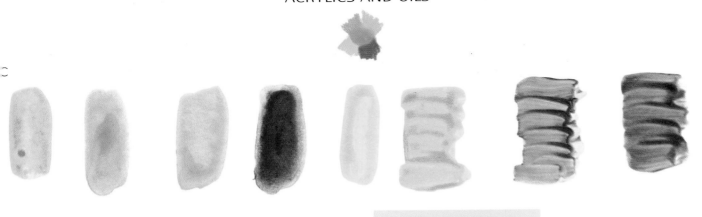

With a large amount of water, the result will be similar to the samples shown here (A); with less water the paint will have the consistency of gouache (B). At the top of this page you can see a palette of greens mixed from the four colors mentioned above (C).

With a square brush you can paint a fine line by applying it on its thin side, and a thick line with the flat side. For fine outlines, we recommend a 0 or a 00 brush.

Is oil compatible with acrylic? It is if you first paint in acrylic and wait for it to dry, then paint over it in oil. It is far too laborious to reverse this procedure, since you would have to wait quite a while for the oils to dry before applying acrylic.

OILS AND MEDIA

Oil paints come in tubes. The paint may be mixed with a medium (with a brush or palette knife) to make it flow more easily. One common medium is a mixture consisting of 60% linseed oil and 40% turpentine.

FLOWERS

*W*e have everything we need: a canvas mounted on stretchers (when using very diluted acrylic it is best to start the picture on a flat surface and then change to a vertical position), tubes of acrylic paint, a palette, water, brushes, etc. Instead of attempting to paint a realistic picture, we will limit ourselves to capturing the atmosphere of the flowers with fresh and graceful strokes. Flowers have always been good subject matter for this kind of brushwork, a technique that can only be achieved by painting very loosely. Don't worry if your picture does not look like the flowers themselves. However, the number of elements and colors should be considered. Here there are three irises: a pale blue one, a bluish white one, and one that is a blue violet, as well as a gladiolus in shades of pink.

MATERIALS

- Medium texture canvas, 18" × 22" (46 × 55cm), stretched or unstretched.
- Flat brush, ⅓", ¾", or 2" (1, 2, or 5 cm), a round number 0 or 00 brush, and filberts in numbers 4 and 8.
- Acrylic colors in tubes: hansa yellow pale, quinacridone red, ultramarine blue, and titanium white.
- Oil colors in tubes: alizarin crimson, burnt sienna, ultramarine blue deep, and violet.
- White porcelain dish for mixing acrylics.
- Two palettes, one for oils and one for acrylic.
- Cotton cloth.
- Linseed oil and turpentine.

The flowers are painted in acrylic. The first layer is diluted with a large quantity of water followed by successive layers of ever-increasing density.

The three irises can be clearly distinguished from each other; they are three different kinds of blue.

Note the existence of clean (unpainted) canvas.

The greens are harmonized with the composition.

For the pistils of the gladiolus, I have used a round brush, number 0 or 00.

1 Let's begin with the acrylic paints. The color used for the sketch should be harmonious with the rest of the color you plan to use. Here you can paint with a very diluted and transparent blue, red, or a mixture.

2 I continue with the stem, an important part of the drawing because it delimits the flowers. I mix yellow and blue, which gives me green. Adding red, I warm the mixture creating a green that harmonizes with the whole. Darkening the blue, I make the lower gladiolus stand out. Working with the number 8 filbert, a fine, flat brush, I apply thicker paint, that is, using less water. I let one flower dry while I paint another. When it's time to return to it, there won't be any problems blending the colors because it will have dried thoroughly.

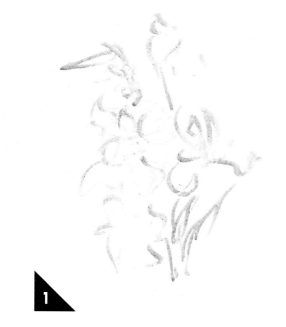

1

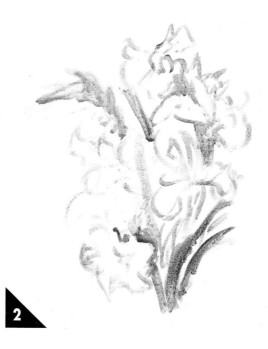

2

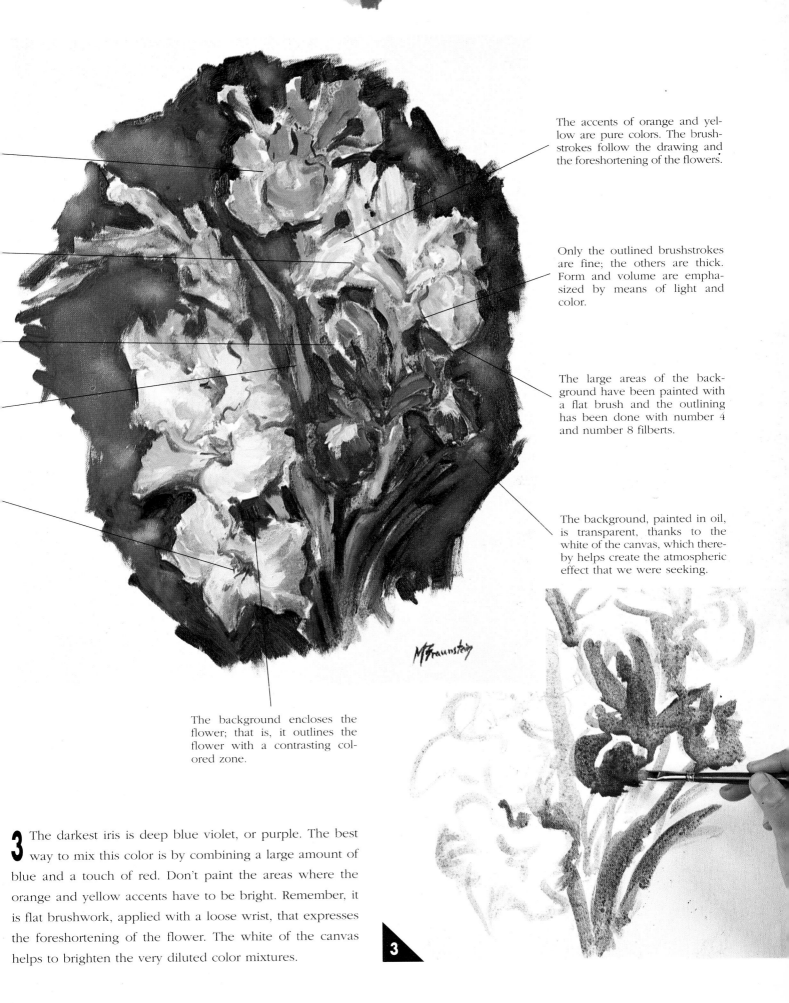

The accents of orange and yellow are pure colors. The brushstrokes follow the drawing and the foreshortening of the flowers.

Only the outlined brushstrokes are fine; the others are thick. Form and volume are emphasized by means of light and color.

The large areas of the background have been painted with a flat brush and the outlining has been done with number 4 and number 8 filberts.

The background, painted in oil, is transparent, thanks to the white of the canvas, which thereby helps create the atmospheric effect that we were seeking.

The background encloses the flower; that is, it outlines the flower with a contrasting colored zone.

3 The darkest iris is deep blue violet, or purple. The best way to mix this color is by combining a large amount of blue and a touch of red. Don't paint the areas where the orange and yellow accents have to be bright. Remember, it is flat brushwork, applied with a loose wrist, that expresses the foreshortening of the flower. The white of the canvas helps to brighten the very diluted color mixtures.

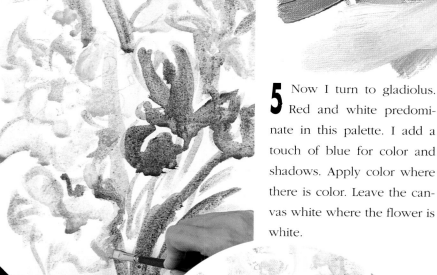

5 Now I turn to gladiolus. Red and white predominate in this palette. I add a touch of blue for color and shadows. Apply color where there is color. Leave the canvas white where the flower is white.

4 With the remaining two irises, I paint the lower flower brighter than the other. I use just a few white and blue brushstrokes to suggest the gracefulness of the petals, their structure, and the way they fall. Looking at a petal, I visualize its shape, and draw it from memory.

6 It's time to prepare the cool whites of the gladiolus. I blend yellow and blue to create a greenish blue. I add a little red and white at my own discretion. (I am trying to mix a greenish yellow-gray.) The green strokes of the stems are brighter than they were in step 2; therefore, I will add more yellow and less red and blue. The yellow, red, and blue that I use are transparent, while the white is opaque. I want to take maximum advantage of these qualities—the parts of the flowers closest to me are painted more opaque; those farther away I leave transparent.

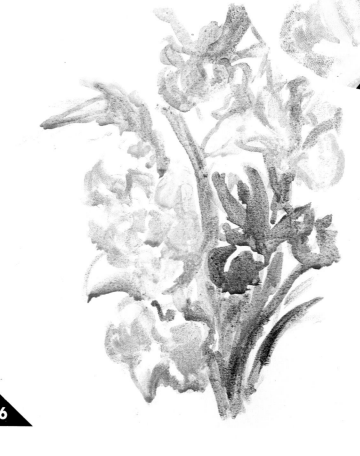

7 I see that the gladiolus has dried. Now I work with thicker paint. White brushstrokes indicate the light; the luminous white is the result of lots of white, some yellow, and a touch of red. I also apply strokes of white in the shadows—a grayish white that I mix using yellow, blue (very little red), and lots of white. I observe the quantity and direction of the strokes.

8 I use warm green tones to bring out the volume and light of the stems—more yellow than red and blue. I give body to the nearest petal of the iris at the top, using white and blue. I paint the petals that point upward with free brushwork. The entire task has been executed with very few strokes.

9 Applying vigorous strokes of color (with a number 0 or 00 brush), I work on the silhouettes and outlines closest to me, differentiating the various planes. Now it is a question of darkening certain areas to create a sense of volume. Note how, in the flower's interior, the petals in shadow have been treated with diluted blue and red so that they can be contrasted with the most opaque zones.

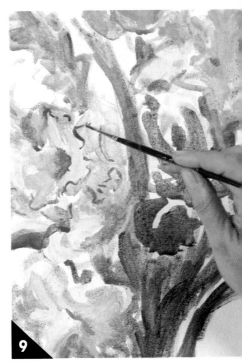

10 I outline the inner plane of the flower. Note the difference in sharpness between the different silhouette strokes; I achieve this by varying the thickness of the paint. There is a hardness in the nearest outlines closest to me that gradually blends into the background. This gives the composition a greater sensation of volume and depth.

11 There is no need to outline all the flowers. It is important, however, to decide which contours to define in order to emphasize the nearest planes of the flowers. This way you create a sense of depth not only by means of color, but also by means of line.

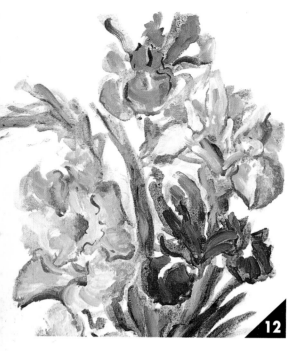

13 With respect to the touches of yellow and orange, the yellow is undiluted, whereas the orange is a mixture of yellow and red. I paint a central orange stroke, and paint yellow on either side. With a small pointed stick (like a stomp), I emphasize the form. If I don't include unpainted areas of canvas, these colors will not appear clean and sharp.

ANALYZING LIGHT IN A STILL LIFE

Look at the flowers without a background. The light shines on the composition from the left. The center of the branch is the lightest part. It is darkened toward the top and the bottom. Highlights, shadows, and intermediate gradations can be seen in the flowers. All this has to be analyzed and the form of the flowers will be developed by the colors applied.

12 I work on the top iris with light purple-blue, indicating the hidden petals (blue, red, and white). I apply strokes of pure white and bluish white to the palest iris. This helps to define the flower while following the outlines established in the previous step. Larger areas are differentiated by being painted with different intermixes of white.

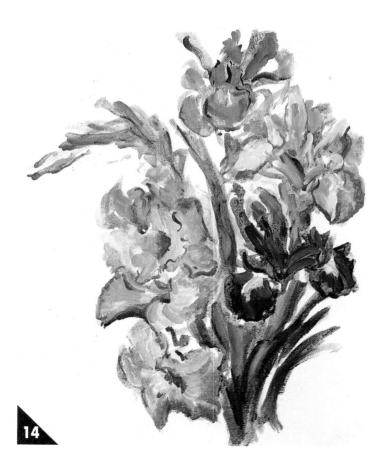

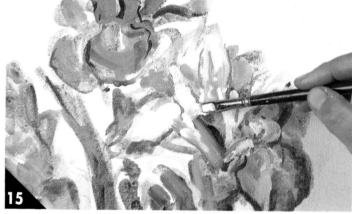

14 Having placed the canvas in a vertical position, I step back and take stock of my work. Each brushstroke of orange or yellow corresponds to the position of each petal, thereby avoiding uniformity of direction of the strokes. Close observation of the picture reveals that the composition lacks light.

15 I bring out the light in the white iris and the gladiolus. By now you will be familiar with the way intermixes of white are obtained by adding touches of other colors. I want to add more light to the stems, so I add white to the greens I have mixed.

16 It's time to again evaluate the work. I strengthen the orange and yellow accents and add more contrast to the stems and shadows. Using a number 0 brush, I apply a few strokes to suggest the gladiolus's petals. At this point, the flowers are sufficiently defined; I'll leave them as they are. I prefer flowers with a fresh appearance rather than an overpainted look. A few spontaneous brushstrokes accomplish this. I immediately clean the dish and the brushes, as acrylic paint dries quickly and permanently.

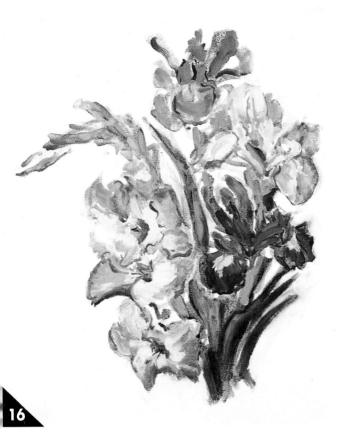

17 Now we start working on the background in oils. Using a number 4 brush, I heighten the foreshortening of the flowers. On the left side there is a shade of red, while the area above and below, as well as the entire right side is darker, more violet. In order to make the flower below the gladiolus stand out, I add several dark strokes.

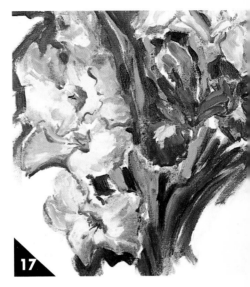

OILS

Now I am going to prepare the background color. When I have finished, I'll clean the brushes and the palette with turpentine. They can also be cleaned with soap and hot water.

To mix the background color, I combine red, alizarin crimson, burnt umber, ultramarine blue deep, and violet. I add some of the medium (60% linseed oil and 40% turpentine) to the paint mixtures on the palette, using a brush to mix it.

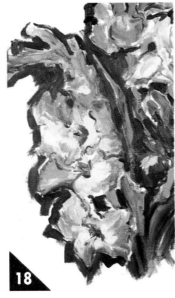

18 I continue working with the number 4 and the number 8 brushes. As a contrast of color and value, I paint several brushstrokes that define the gladiolus. Note how the flowers stand out. I keep the strokes free and loose.

19 Now, with the flat brush, I fill in the background with a thick layer of paint. The tone is slightly red where there is more light. Gradually, where there is less light, the tone takes on nuances of alizarin crimson, violet, or burnt sienna.

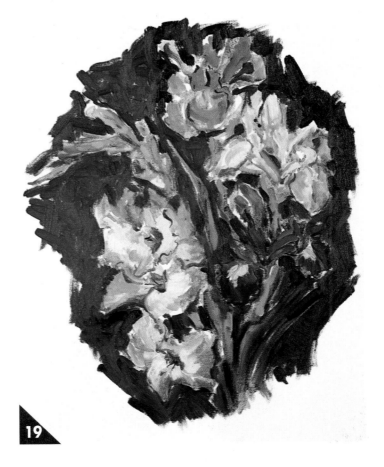

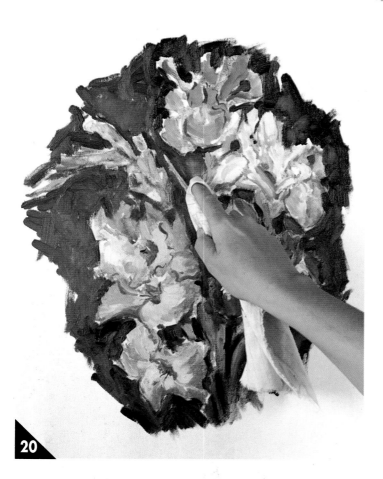

20 This is the way you hold the cotton cloth to work on the background. Bear in mind that if you have not applied a thick layer of paint, you will not be able to successfully perform this task.

21 Don't attempt to rub off the same amount of paint over the entire background; only remove what is necessary to create the nuances of hues you need. These hues and tones are the result of the transparent effect of the oil paint layer, which allows the white of the canvas to show through. Note that I leave only a few of the outlines in the background and some around the flowers.

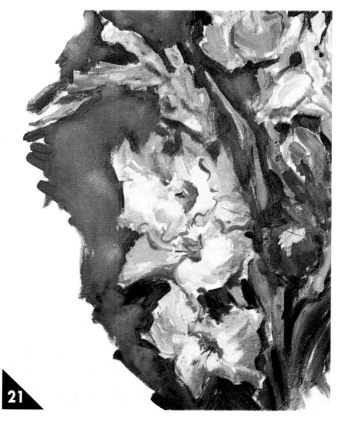

22 I reduce the intensity of the color to express the light that passes behind the flowers. If this is not done, the flowers will appear to be glued to the background. Stand back from the picture and observe the result. You should be able to see how the background acquires rhythm.

23 I think we can consider the exercise finished, but remember, you can paint over acrylics in oil. Why not try it? If you are not satisfied with one of the flowers, go ahead and paint over it in oil. You will learn by your mistakes as you choose the colors for your work. You will see for yourself how the flowers acquire more body and volume. In this way, it is possible to obtain more contrast between the flowers and the background.

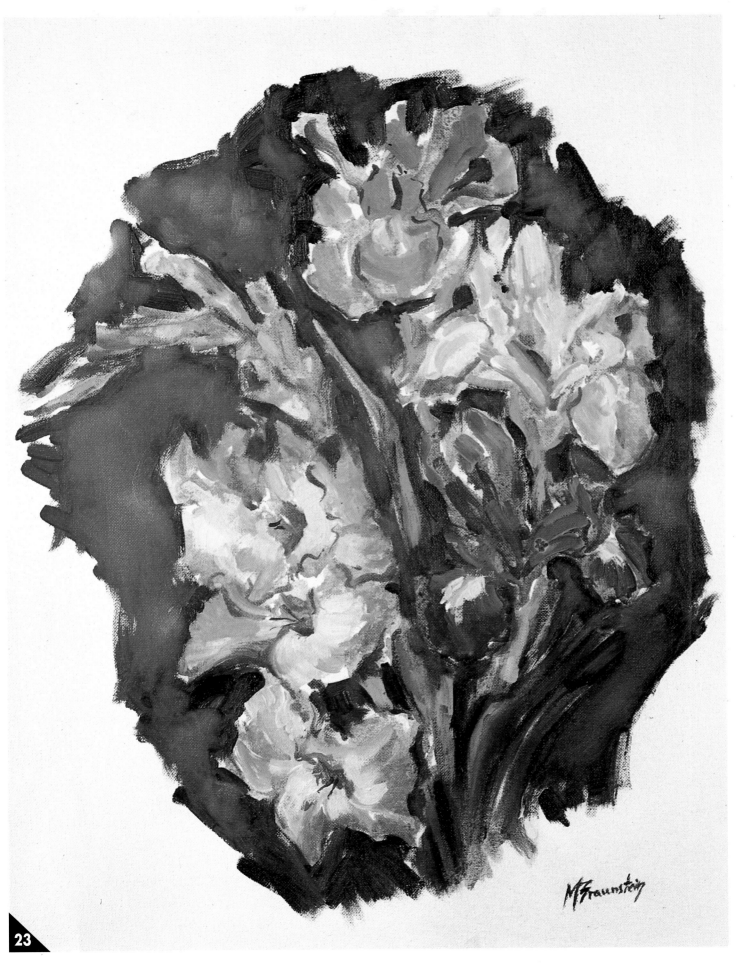

INK, SEPIA, AND SANGUINE CONTÉ PENCILS

It is common practice to combine pure ink with diluted ink. For instance, when an artist works with pure ink, the shadows are represented by crosshatching, a grouping of dots, etc. Any attempt to use a brush will create very hard shadows when working on small pictures, but with the use of diluted ink, it is possible to obtain the most delicate of shadows.

What do we mean by diluted ink? Quite simply, a kind of wash consisting of ink diluted with water, preferably distilled water. By varying the proportions of water and ink, you can mix different values; thus, with more water you obtain a lighter value. So, by diluting ink, you can execute an entire picture using only one or two colors, which are varied in value depending on the intensity of the light.

I am going to use this medium for a subject I have called *Boy Reading a Book* because I want to express the poetry and the intimacy of the scene with a few free and spontaneous strokes, and work with a harmonious, melodic color. All this can be achieved with pure ink and diluted ink. The combination of two inks, one a sepia color, and the other a burnt sienna, enables me to treat the shadows cast by the boy and the bushes with great delicacy. My aim is to use the sepia tone in the lightest areas and, by means of diluted inks, gradually darken the shadows with burnt sienna. Winsor & Newton inks, which are long-lasting, excellent colors, are suitable for mixing.

The white of the paper is useful for creating halftones and for silhouetting (leaving a profile around something in white).

In general, ink is an ideal medium for treating objects, but can make features, hands, or nudes appear harsh. Whenever I want to capture the softness of naked skin, I include variations of a color somewhere between the color of the skin and the objects. I normally add pastel colors or similar media consisting of pigment powders. Here, using the pigment from sanguine and sepia-colored pencils, I'll draw the facial features and the movement of the hands with a small stomp. Sepia and sanguine are colors that blend well with the ink colors I have chosen.

A

For this exercise we are going to use a brush, a pen-holder, and a stomp.

Note the difference between the straight, rigid strokes and the freer strokes. More ink is left in some places than in others, and this is one of the advantages of this medium (A).

To master the drawing pen you have to learn how to obtain a uniform ink flow without applying too much pressure on the pen. In addition, you have to know how to vary the pressure in order to control the strength of the line, that is, the width of the line and the intensity of the color (B). You have to use a soft nib that allows you to control the ink flow, which gives you more freedom of expression. That is the beauty of the pen.

Try it out for yourself before attempting this exercise. Practice on a piece of paper until you have a range of diluted ink tones (with sepia and burnt sienna ink). See how one line over another produces a dark color. Also mix both inks together. Another good way to practice is to draw several fast sketches without worrying about making mistakes.

The washes in this exercise are also small. I have to use them because there are areas that cannot be covered in one single brushstroke, but, given the nature of the composition's design, I don't need flat or uniform washes. They are easy enough to do—simply load a thick brush with color and brush it over the area to be painted. Remember that any stroke applied on top of a wash will be clear.

The graduated wash on the right (C) is obtained by varying the proportions of ink and water. As you will see, I am going to use many small washes during the exercise.

I attach the paper to a drawing board or firm surface that I tilt slightly, since I want gravity to force the ink to run and settle where it is needed.

CORRECTING MISTAKES IN INK

Ink drawings cannot be changed very easily. If you need to correct a line or stroke, apply blotting paper immediately. If the paper is strong enough, you may be able to remove the color with water and then let it dry. Wait until it is completely dry before scraping the surface with a knife. Last, using the flat side of your fingernail, smooth down the surface. As you can see, it is a somewhat laborious process; furthermore, paper loses its gloss and the repainted area usually appears overworked.

B

C

BOY READING A BOOK

*B*y looking at the scene with half-closed eyes, we can see the light coming through the shrubs, illuminating the figure from behind. How can we capture that? We will use areas of graded washes. First, I sketch the composition with a soft pencil. Then I pick up the brush and, loading it with diluted ink in the appropriate color and value, I apply the first strokes. They should suggest the direction of the light, the intensity of the shadows cast, and follow the drawing.

MATERIALS
- Drawing paper 14" × 20" (35 × 50 cm).
- Drawing ink: burnt sienna and sepia.
- Watercolor brushes: Number 4 flat brush and number 6 round brush.
- Automatic pencil with HB lead and eraser.
- A penholder with a fine nib.
- Razor blade or cutting knife.
- Sepia and sanguine Conté pencils.
- Small stomp.

1 I draw a sketch with the HB drawing pencil, working very lightly. For the moment we need only concentrate on placing the figure, and not attempt to execute a detailed drawing. It is useful to know how to block in the figure with several guidelines to indicate foreshortening. The foot and leg on the left are closest to us and the proportions should be carefully drawn. Note how the left leg is more bent than the other one.

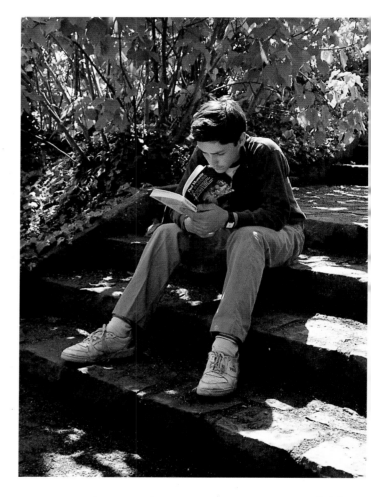

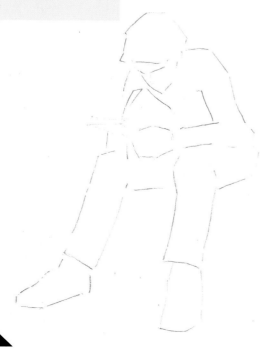

1

2

Here it is important to establish the correct intensity of the background with respect to the rest of the work. Don't try to draw each individual leaf.

The darkest shadows are made with undiluted burnt sienna. I paint the other shadows in diluted ink.

The sepia ink is the warmest of all the colors we are using; therefore, it is logical to paint the areas that are in the brightest light with washes of sepia ink.

The figure is the most important element in the picture; therefore, I place it in the center. The lines of the steps, as well as the distribution of the shrubs, focus attention on this central figure.

The harsh shadow cast on the steps by the boy and the shrub is softened as I begin to apply the ink wash of sepia and burnt sienna. It is important to bear in mind that the composition's center of interest—the boy—should stand out as a result of greater tonal intensity and more body. On painting the lighted zones of the steps in diluted sepia, the contrast with the shadow cast by the shrubs and the boy is sufficient.

The only element that breaks with the harmony of the composition of ink washes laid down are the lines drawn with a pen using undiluted burnt sienna ink.

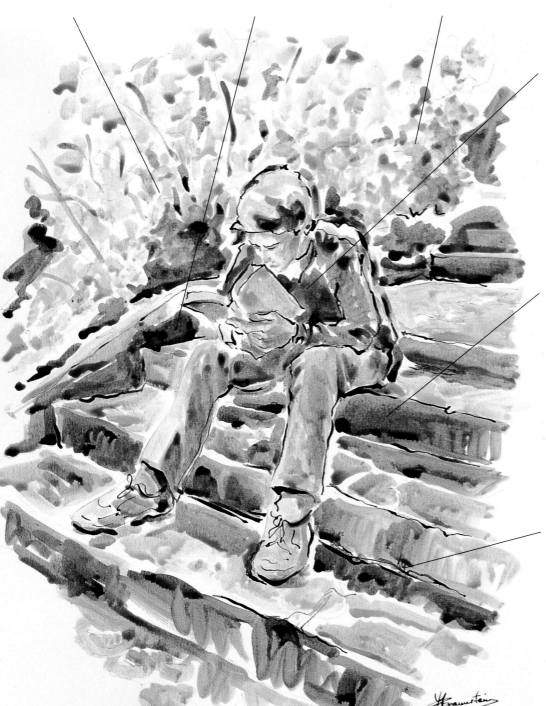

2 I finish the sketch by adding lines to indicate the flight of stairs as well as to suggest areas of light and shadow. I also quickly sketch the shrubs that fan out behind the upper part of the figure.

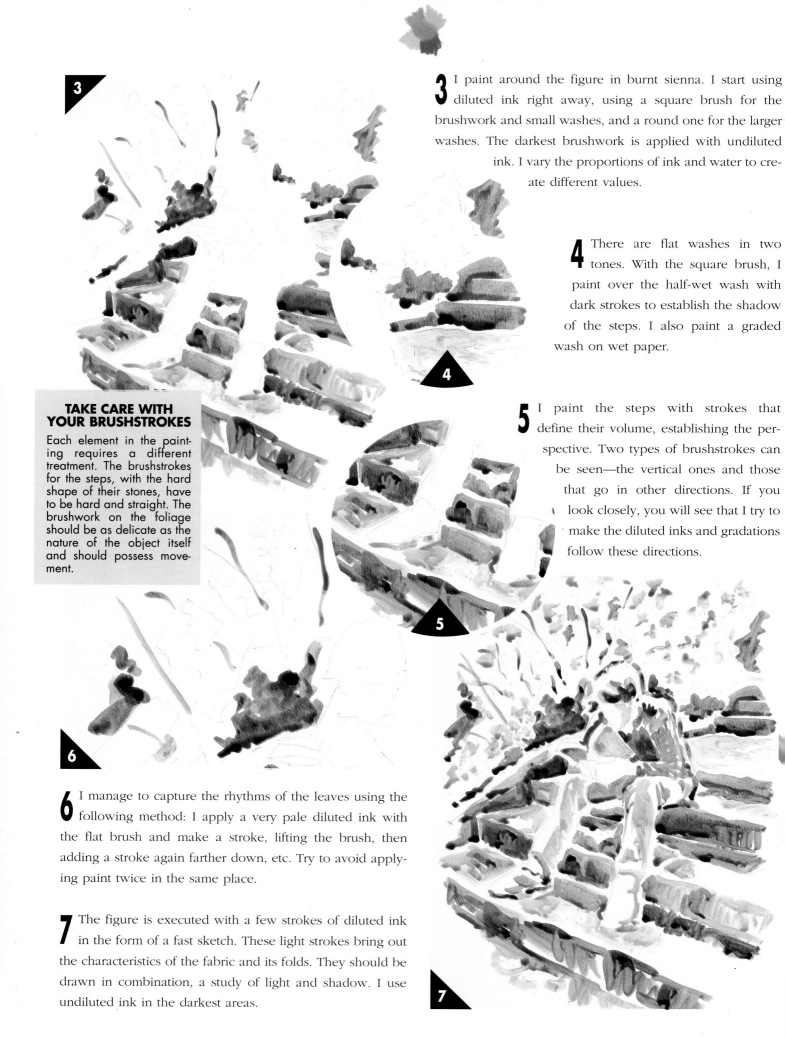

3 I paint around the figure in burnt sienna. I start using diluted ink right away, using a square brush for the brushwork and small washes, and a round one for the larger washes. The darkest brushwork is applied with undiluted ink. I vary the proportions of ink and water to create different values.

4 There are flat washes in two tones. With the square brush, I paint over the half-wet wash with dark strokes to establish the shadow of the steps. I also paint a graded wash on wet paper.

5 I paint the steps with strokes that define their volume, establishing the perspective. Two types of brushstrokes can be seen—the vertical ones and those that go in other directions. If you look closely, you will see that I try to make the diluted inks and gradations follow these directions.

TAKE CARE WITH YOUR BRUSHSTROKES

Each element in the painting requires a different treatment. The brushstrokes for the steps, with the hard shape of their stones, have to be hard and straight. The brushwork on the foliage should be as delicate as the nature of the object itself and should possess movement.

6 I manage to capture the rhythms of the leaves using the following method: I apply a very pale diluted ink with the flat brush and make a stroke, lifting the brush, then adding a stroke again farther down, etc. Try to avoid applying paint twice in the same place.

7 The figure is executed with a few strokes of diluted ink in the form of a fast sketch. These light strokes bring out the characteristics of the fabric and its folds. They should be drawn in combination, a study of light and shadow. I use undiluted ink in the darkest areas.

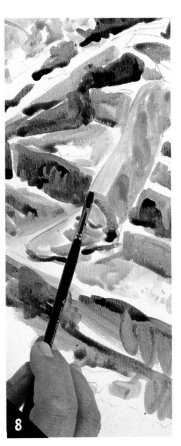

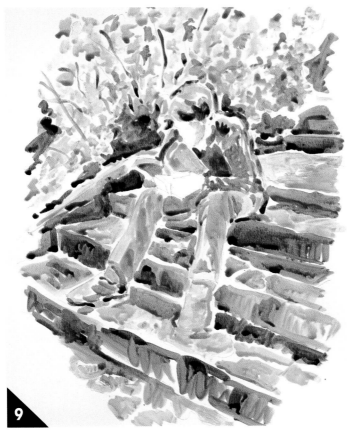

8 I begin working with sepia ink. For the half-tones of the pants and sneakers, I use a very dilute ink wash. I begin to develop the background and the rest of the figure. What is important in the background is the quality and amount of light.

9 You can better see the different values of sepia in the background by looking at it with your eyes half-closed. For the shrub's half-tones, I mix sepia and burnt sienna inks with water. The head, shoulders, and book all have intense points of light. For that, I'll use undiluted sepia ink. I lighten the steps with diluted ink and sepia ink creating softened gradations.

10 At this stage we begin working with the pen containing burnt sienna. I outline only the figure and the steps; there is no need to outline everything. I use only a few lines to suggest the most important features. It is best to first analyze your composition, then decide what to emphasize as you develop your sketch. The face and hands are sketched very lightly.

PRESERVING WHITE PAPER

White serves a double purpose. I use it as one of the values or tones in the composition and for outlining. A work in ink may appear overworked if no areas of white paper are left. By leaving areas of white paper unpainted, I add contrast and maintain a fresh quality in the work.

11 Using a cutter or a razor blade, I file down the Conté pencils to get some sanguine and sepia powder. This will be used with a very small stomp.

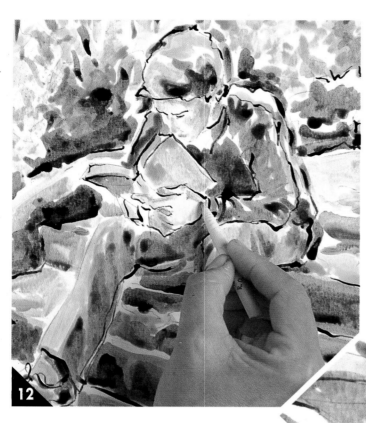

12 Here, on the hands, the paper is left white to represent the lightest areas. I dip the tip of the stomp into sanguine powder and sketch the first suggestion of shadows. The first few times you draw hands, you may make them appear more like claws, a common error for beginners. This can be avoided by careful observation and lots of practice.

13 I finish developing the three-dimensional quality of the hands using a stomp with the sepia and sanguine powder. It is important to look carefully at the gradations of tonal intensity. Note the shadows on the index finger and thumb and along the side of the hand, which accentuate the structure of bone and muscle.

14 I begin to suggest the face with a wash of pale burnt sienna. On the neck, I paint a stroke of sepia and lightly draw three lines with the pen. As I did with the hands, I again use stomps with sepia and sanguine powder to develop the form and volume of the face. Here the darkest shadows are along the nose and around the mouth and eyes. I also use the stomp to soften the area of shadow along the forehead, the temple, and the cheek.

KNOWING HOW TO CHOOSE

The artist must decide what to retain or eliminate when beginning a composition. The artist has to observe, analyze, and know what he or she wishes to express. This is all part of the exercise.

15 I believe there exists a delicate harmony in this work. It is a descriptive and expressive picture. The atmosphere of the setting is one of warmth and intimacy, which is reflected in the softness of the colors selected as well as the subtle gradations of value.

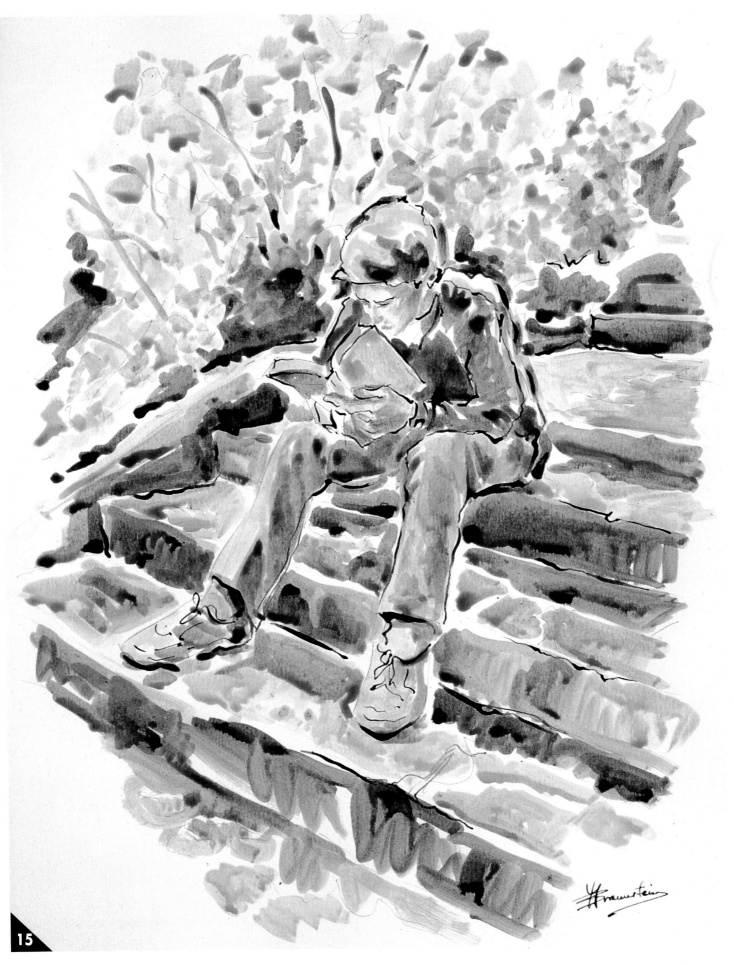

WAX CRAYONS, PASTELS, AND ACRYLIC PAINTS

Wax crayons are solid colors that come in cylindrical sticks. They can be used by rubbing the tip or the side of the crayon on paper. Pastels are solid colors that also come in sticks. When they are rubbed on a paper surface, the colored pastel powder is deposited. Although they are similar to pastels, wax crayons have special characteristics. The wax lends the color luminosity. Although crayons are essentially opaque, they are more transparent than pastels, and spectacular effects can be obtained with them.

Wax crayons and pastels adhere to the paper in different ways and the results of blending with a stomp differ. What happens if you combine pastels with wax crayons? Pastels adhere to wax crayon better than they adhere to clean paper. If the process is repeated, with more wax and more pastels, areas of colorful impastos and textures are created. As you will shortly see, the effects are interesting.

A picture colored with crayons can be painted over with acrylic paints. Diluted with lots of water, acrylics look like watercolor; with less water they have a thicker consistency like *gouache*. Why is it interesting to combine these two media? Because the artist can play with the following contrasts:

• Acrylics have a matte finish; wax crayons have a lustrous, shiny finish.

• With acrylics one can outline easily and with a great deal of precision (with a fine brush).

A

a cutter or a razor blade, in the same way one would extract a thin film. The paper is then left with a slight mark and a little color (it is stained). Another method is to remove the wax with a cloth and then erase the area with an eraser, although there will always be a slight stain.

How are pastels and wax crayons used? Any part of the stick can be used for painting. Depending on the amount of pressure you apply to the tip, the corner, or the side, the stroke will be thicker or thinner.

Brushstrokes of acrylic paint are different from strokes made with a wax crayon. Some pastel can be erased by rubbing a cotton cloth over the affected area, then going back over it with an eraser.

On the other hand, wax crayon sticks to paper; therefore, it should be removed by scraping with

BLENDING

Blending pastels and wax crayons can be done by rubbing lightly over the color on the paper with the tip of your finger, a piece of cotton cloth, or a stomp. In the case of wax crayons, it is the heat of the friction that spreads the color. With pastels, rubbing creates an opaque effect, since they are made of compact powder. By gently rubbing, color can be blended and smoothed, and beautiful areas of light and shadow developed. This is one of the characteristics of both pastels and crayons.

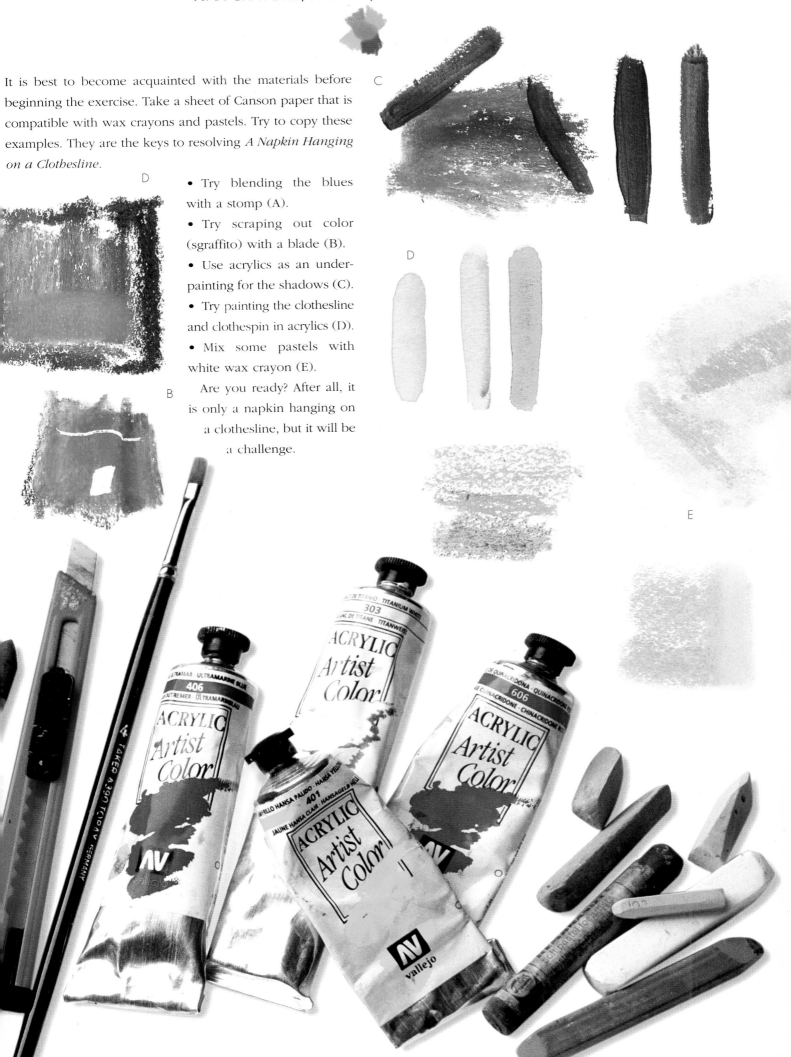

It is best to become acquainted with the materials before beginning the exercise. Take a sheet of Canson paper that is compatible with wax crayons and pastels. Try to copy these examples. They are the keys to resolving *A Napkin Hanging on a Clothesline*.

- Try blending the blues with a stomp (A).
- Try scraping out color (sgraffito) with a blade (B).
- Use acrylics as an under-painting for the shadows (C).
- Try painting the clothesline and clothespin in acrylics (D).
- Mix some pastels with white wax crayon (E).

Are you ready? After all, it is only a napkin hanging on a clothesline, but it will be a challenge.

A NAPKIN HANGING ON A CLOTHESLINE

*I*t is simple—*look at the napkin hanging on the line. Notice that the foreground poses some difficulties. Thanks to the techniques and the combination of media I will use in this composition, I am going to create an effect of volume and depth.*

I'll paint the napkin in wax crayons. I'll use a white wax crayon and pastels on the wall, working softly to suggest the stuccowork. In the final phase, I'll use acrylic paints first, to paint the line and clothespin, and, second, to outline the napkin.

MATERIALS

- White Canson Mi Teintes paper, 19½" × 25½" (50 × 65 cm).
- Wax crayon colors: pale ocher, pink, carmine, purple, burnt sienna, blues (three or four tones), greenish blue deep, carmine violet deep, 2 or 3 white crayons, a pale gray, and a dark gray.
- Acrylic paint in tubes: titanium white, hansa yellow pale, quinacridone red, and ultramarine blue.
- Number 4 flat brush with a square head and a number 0 round brush.
- Cotton cloth.
- Knife and palette knife.
- White plate.
- Pastels (soft pastels): pale ochre, pinkish ochre pale, pale gray, and dark gray.

The clothesline and the clothespin are painted with acrylic paints of a gouache consistency that produces a matte finish that is different from the rest of the work. Although it forms part of the foreground, it does not take precedence over the napkin.

The wall has been blocked in with pastels and white crayon, which enables me to bring out the stucco without any hardness in the texture or the shadows. The use of a more striking medium to paint the napkin makes it stand out from the wall.

Painted in wax crayon, the napkin creates a strikingly visual impact. This is the result of combining media such as wax crayons, working with a knife and brushstrokes of acrylic paints.

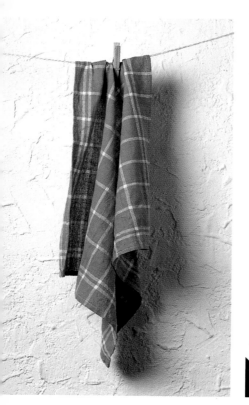

CHARACTERISTICS

Canson paper is excellent for pastels and adequate for wax crayons. It is adequate for this combined medium picture, since it can also absorb acrylic paint. I will paint on the smooth side of the paper. This way, I won't have problems scraping color away with a knife or similar object. If I use the rough side, the color would fill up the holes of the grain, which would not produce the desired result.

1 I sketch the napkin, the clothesline, the clothespin, and the cast shadow in pale green crayon. I show how the cloth falls by blocking in the main folds.

2 I continue with the pale gray crayon, indicating the shadows cast by the napkin. Then I go over the first sketch with more artistic strokes.

3 I am going to block in the entire napkin with white wax crayon. Note how I use the flat side of the crayon to apply sweeping strokes across the paper.

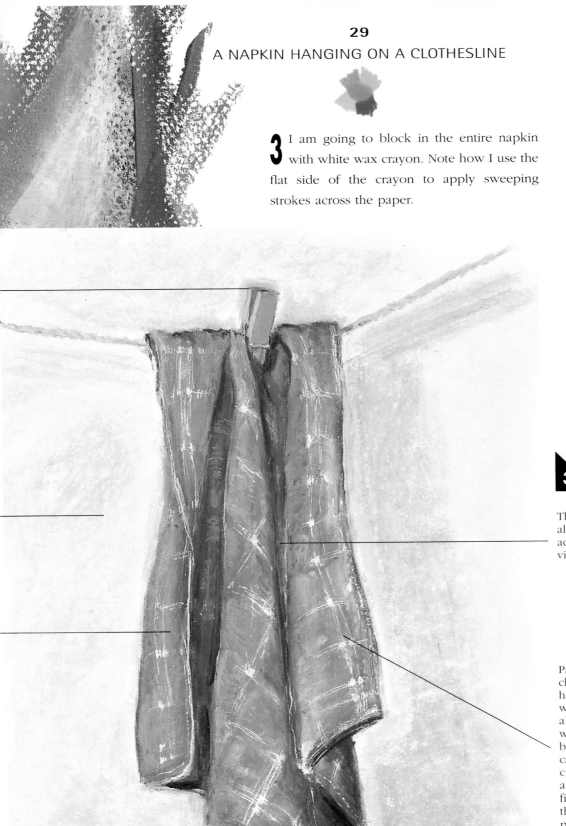

The acrylic paint on the napkin allows me to enrich the work by adding more strokes to the previous ones done in wax.

Pay attention here. The masking characteristics of white crayon have been used in the following way:
a) the napkin is covered with white wax crayon;
b) color is added on top (blues, carmine, violet, etc.);
c) the wax is then removed with a razor blade to create the sgraffito of the squares and lines of the napkin. The white wax preserves the white of the paper, which is retrieved using a knife or razor blade.

I emphasize the contour of the napkin to create contrast. For instance, I can outline in a bright tone with the knife, or do it with dark colors that contrast with the color of the napkin (carmine, violet, umber, greenish blue deep, etc.)

4 The napkin is now entirely covered in white. Here the gray of the shadows gives a sense of volume to the object. See what can be achieved with only two colors.

5 To paint the napkin, I add: a) a touch of blue (two tones, light and dark); b) next, I paint the two parts of the shadows. First, I lay in the warmest colors (carmine and purple), which is due to the reflection of the light on the wall behind the napkin, and, second, I add the deeper shadows (violet and dark blue) on top of the lighter color.

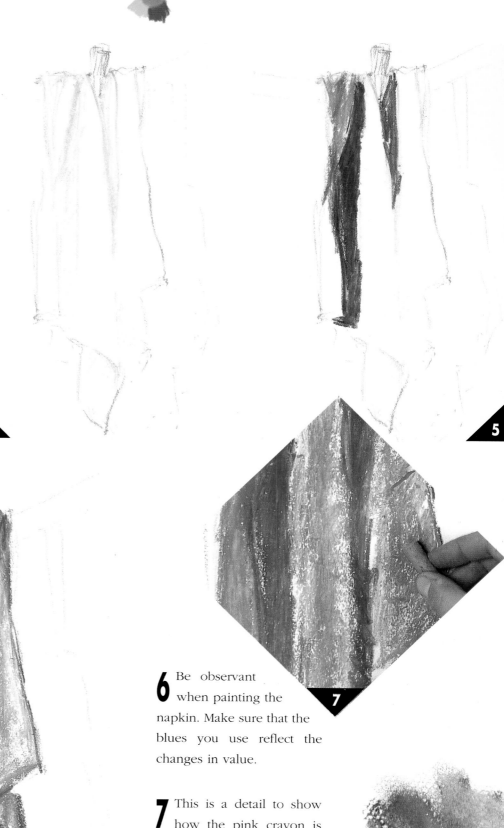

6 Be observant when painting the napkin. Make sure that the blues you use reflect the changes in value.

7 This is a detail to show how the pink crayon is applied. But why pink? The answer lies in the napkin. It isn't blue. It is the result of blending blue, red, and white. In addition, pink is an appropriate color for adding highlights and reflections.

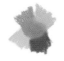

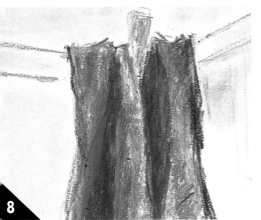

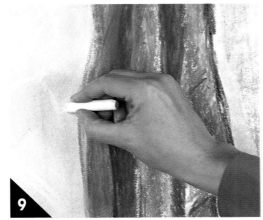

8 I add a touch of color to the clothespin and the line: pale ochre, sienna, umber, etc. Now I begin working on the wall in pastel. I apply pale ochre and pale gray pastel, using the flat side, paying attention to the direction of the light.

9 I continue working on the wall. Now I paint strokes of white wax crayon over the paper that has been colored with pastels. I make strokes that suggest the stucco of the wall.

10 Now see what I achieve by painting over this combination of pastels and white wax crayon with yet another pastel color, this time pink ochre. Where the wax adheres most, it takes on a different color, and the stucco begins to emerge.

11 I continue working on the shadow cast on the wall. I add dark gray pastel to the pale gray and ochre painted earlier. I will lighten it with white wax crayon as I see fit to avoid a harsh appearance. Note how the lighter color on the right distances the napkin from the wall, and at the same time indicates the direction of the light.

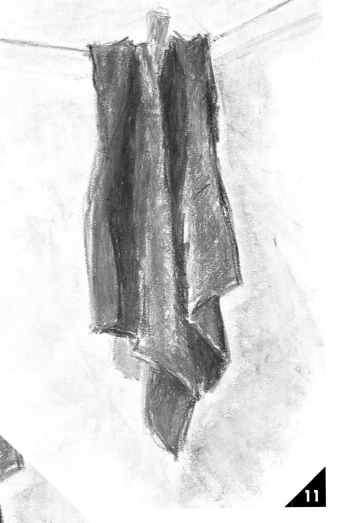

12 This is one of the most attractive steps. I am going to bring out the form of the napkin by blending with the tip of my finger. The best way to do this is by rubbing in a horizontal direction, from left to right, and then in the opposite direction.

13 Using my finger, I now blend in a vertical direction, from top to bottom, and then the other way around.

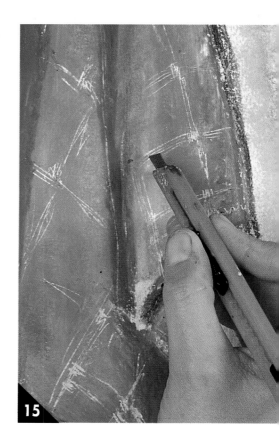

14 This is the current state of the napkin and the wall. Be careful now as the drawing can get lost by overblending. I correct it where it is necessary. I can apply more wax crayon and blend it again.

15 I start the sgraffito, using a cutter. I remove sections of color to expose the white paper, which here represents the squares and lines of the napkin.

16 Two important details to point out: I add more highlights with pink crayon; also, I use the cutter to outline the highlights and white areas.

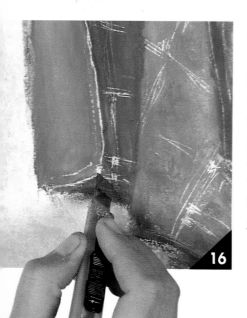

17 I add contrast to the shadow in the creases of the napkin (dark blue, dark violet, carmine, purple). I also blend the clothespin with carmine, for instance, and add some touches of color to suggest highlights (ochre over blue gives me a greenish tone.)

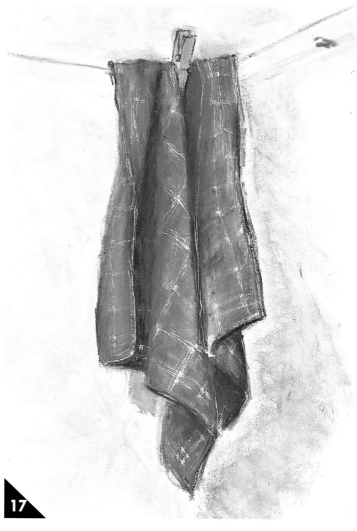

18 I darken the edge of the clothespin with an umber wax crayon using the pointed tip.

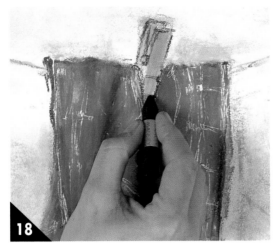

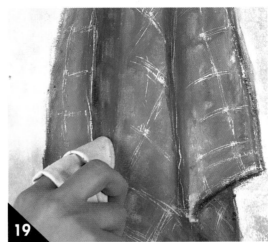

19 Notice how I remove the color with a cloth. There are two advantages to coloring the entire surface of the cloth with white: a) the sgraffito of squares and white lines is simpler because of the white underneath the color; and b) the color on top of the white is toned down and, in addition, is easier to remove with a cotton cloth.

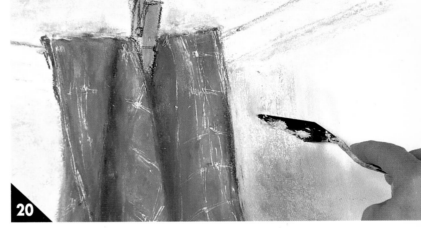

20 The palette knife is not necessary if you know how to use the cutter. However, a palette knife does come in handy for removing the mixture of crayon and pastel. By scraping you can redo the texture of the stucco, going over it with either pastel or crayon.

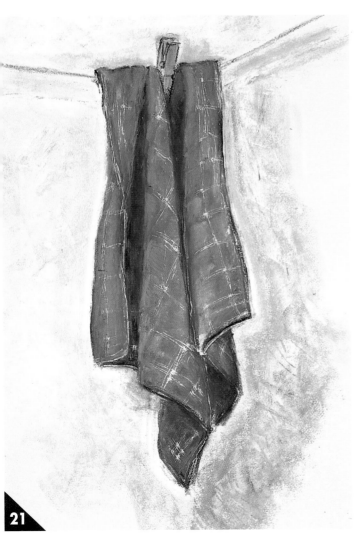

21 I work on the wall and add more contrast to the shadows of the napkin. The painting requires continuous adjustments to establish the best color relationship.

22 Before beginning with the acrylic paints, I use fixative (spray) on the wax crayon and the pastel so that the acrylic will cover it more easily.

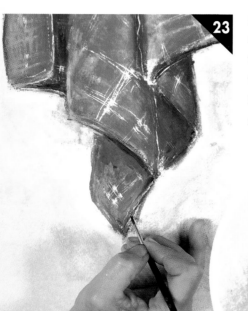

23 I paint with acrylic paint thinned with water to a gouache consistency but there is no need to prepare a large quantity. I paint red and blue (carmine-like violet) strokes to reinforce outlines, using a number 0 brush for fine lines.

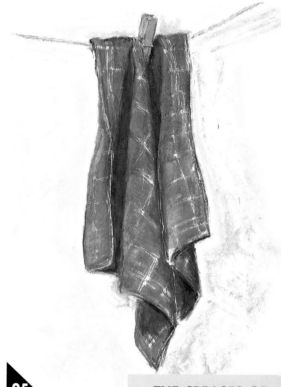

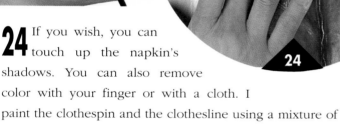

24 If you wish, you can touch up the napkin's shadows. You can also remove color with your finger or with a cloth. I paint the clothespin and the clothesline using a mixture of yellow, red, and white, varying the proportions as I work. You shouldn't have any problem at this stage, since the covering powers of acrylic make it very easy to work with.

25 This is the best time to evaluate the work, to see what needs adjusting. Take a break for a few minutes—you'll see everything clearer when you return to the work.

THE CREASES OF FABRIC

To express the volume of folds and creases of fabric you can use two media: wax crayons and acrylic paints. It is essential to capture the way the fabric falls. Draw and paint it at the same time. With wax crayons and pastels, use fingers, cloth, or stomps to blend color. With acrylics, brushstrokes can be added last to indicate highlights and shadows.

26 I decide to brighten the shadows cast on the wall with ochre and pink pastel colors. I also lighten the clothespin with a second layer of acrylic paint. The interior shadows of the napkin are harsh, so I soften them by rubbing with a cloth. Last, I apply the highlights on the napkin with acrylic colors: pink (white and red) and greenish yellow. You can do this with crayons if you wish. The picture is now finished. I congratulate you, no matter what the result of your picture might be. The very fact that you have reached the end is the sign of a job well done. Among other things, you have become acquainted with different materials, you have practiced drawing, and you have learned about color. I think you have achieved a great deal!

A NAPKIN HANGING ON A CLOTHESLINE

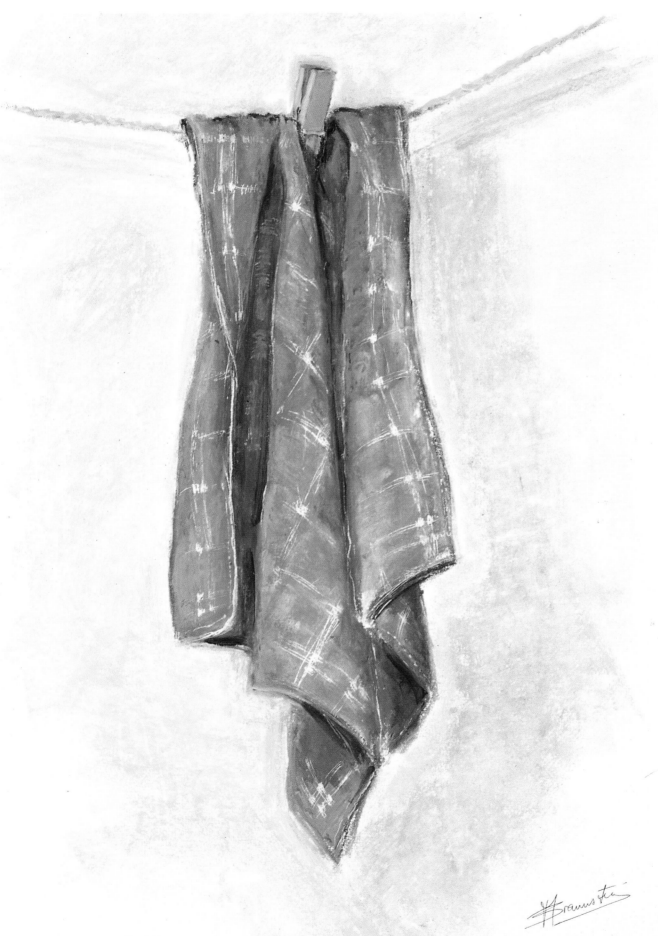

ACRYLIC MODELING PASTE, PASTELS, AND ACRYLIC PAINTS

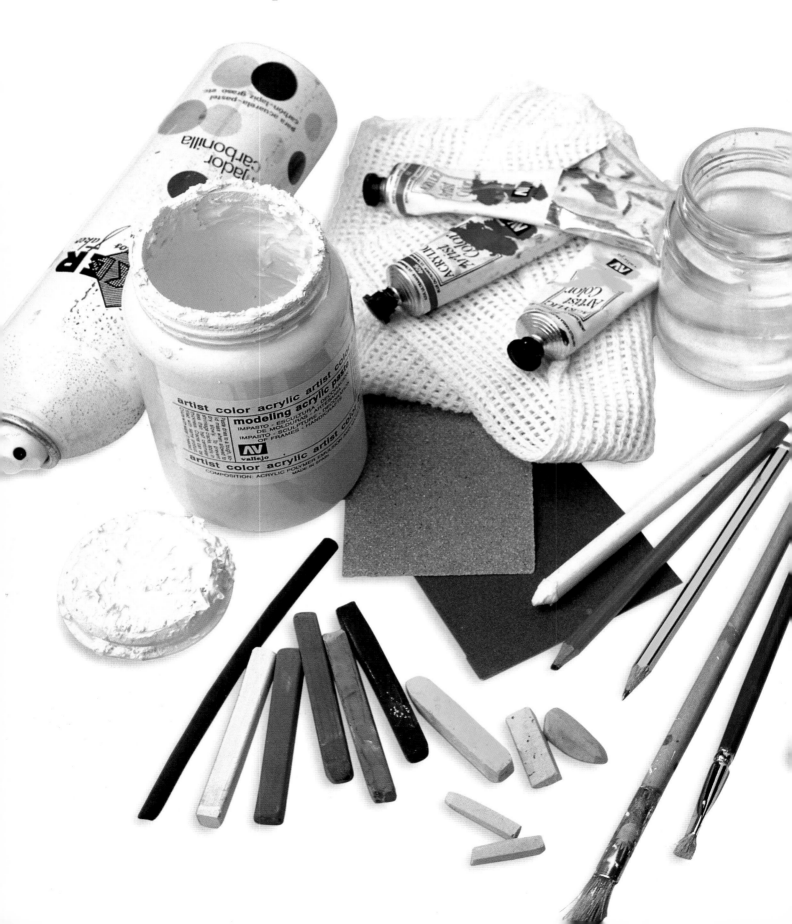

Acrylic modeling paste can be purchased in tubes and jars. I recommend the jars, because I am sure that you are going to love working with this medium and, therefore, will want to keep it for use in the future. It is used exactly as it comes out of the jar, applied with a brush or palette knife. The paste is white and adheres to clean surfaces. The best time to work on it is when it is still wet but does not stain or dent when pressure is applied on it. You can use just about any instrument to scratch and scrape sgraffito in order to obtain a specific texture. Once the paste is dry, it becomes very hard and is difficult to model.

Pastel adheres well to acrylic paste. I normally use hard, square pastel sticks because they do not crumble when applied to a textured surface. This enables me to mix pastel colors together and blend them. The powdery pigment penetrates and settles in thick layers within the grooves of the paste. In addition, it is possible to change it by erasing with a rubber eraser.

Note the following:
• Blending pastels is done by lightly rubbing with a finger, paintbrush, cloth, or stomp.
• The juxtaposing of two colors of distinct tones may accentuate them both, making the light tone appear brighter and the dark tone darker (an effect of pastel in the grooves of the modeling paste). With acrylic modeling paste and pastels you can produce a complex, twisted three-dimensional work in relief.

On the other hand, if you paint the modeling paste with very dilute acrylic paint, you get a completely different result from that obtained with pastels. The combination of thinned down acrylic paint colors the acrylic modeling paste and the paper. Any changing has to be done by scratching the painted surface away with a razor blade or rubbing with sandpaper, which is a laborious task. Therefore, it is more convenient to use pastels to add nuances of color to the acrylic modeling paste, and very diluted acrylic paint for large open areas. Bear in mind that the acrylic finish is extremely clean, which will contrast with the powdery effect of pastels.

To illustrate how these two media can be used together, I am going to show you how to paint a sneaker and the shadow cast around it. I will leave the texture of the paper visible in order to contrast it to the relief of the paste. I will paint the sneaker in pastel, since I can obtain different hues with this medium, and I'll paint the shadow and the background in acrylic washes. Some of the more important aspects of this exercise include the blending of pastel colors with a brush. See the examples of combinations of colors, one with dark gray, sienna, and ochre, toned down in the center with white (A); the other, with sienna, pale gray, dark gray, and black (B).

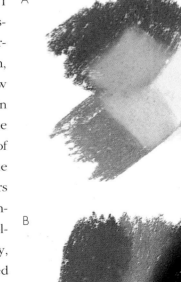

A

B

A SNEAKER

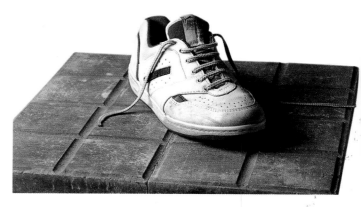

A sports sneaker (tennis shoe) is a very popular item in just about every home. It should be one of the first things you try to draw. By using combined media, you will achieve very special results. The worn sneaker, depicted in relief, will be expressed through the texture of the acrylic paste. The paper you use must be strong and have the capacity to absorb the acrylic washes. It should be attached to a board of some kind with scotch tape; this will prevent it from warping, although it is important to remove the paper from the board in order to dry it. At any rate, if you don't attach the paper, even if it does warp, it will regain its original flatness a short time later.

1 I draw the model with an HB pencil, sketching loosely to define the sneaker and its shadow. Don't concern yourself with corrections because the acrylic modeling paste will cover the pencil marks. What is important at this stage is to indicate the foreshortening and draw the way the laces fall. Throughout the entire process, consider the shadow and the tile on which the sneaker stands.

2 Using a number 10 brush I begin to apply the acrylic paste just as it comes out of the tube or jar. If you find it is slightly thick, add a drop of water and mix. As always, the brushwork should emphasize the three-dimensional form.

MATERIALS

- Cold-pressed watercolor paper (140 lb.) 16" × 18" (40 × 45 cm).
- A tube or jar of acrylic modeling paste.
- Short flat brush ⅔" (1.5 cm) and two square brushes, number 6 and number 10.
- A number 2 watercolor brush.
- An HB pencil, a 3B black Conté, and a soft eraser.
- Modeling instruments, a cutter, a screwdriver, and sandpaper.
- Pastel colors: white, sienna, ochre, pale gray, dark gray, and black (the hard square type)
- Acrylic colors: hansa yellow pale, red quinacridone, and lamp black.

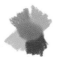

I mix small amounts of yellow and red acrylic with a lot of water for grading the background. I want to mix a honey color; therefore I vary the proportion of water.

I use a white porcelain dish for mixing acrylics. Its brightness against the bottom of the dish gives me a good idea of what it will look like on the acrylic paste or the white paper.

I apply acrylic modeling paste to represent the sneaker. Once it is modeled and dried, I start painting pastel over it. I apply a layer of the modeling paste to create the shadow and then paint it with acrylic paints.

The darkest shadow (below the shoe) is added, using sienna and black pastel. This is superimposed over the acrylic underpainting.

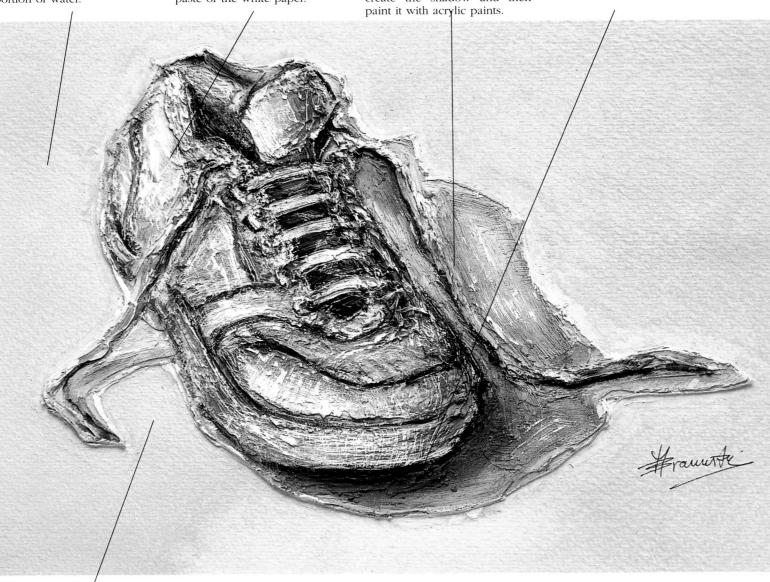

Note the texture of the paper—the wash with diluted acrylic colors makes it even more evident.

3 Remember that the direction and kind of stroke I use are very visible at this stage. To bring out the thickness of the relief without causing cracks, it is best to apply the paste in several thin layers. I apply the first layer, leave it to set a little, then apply the next one, and so on.

4 The laces are indicated by a thin application of acrylic paste. I load the paste on the underside of the palette knife and, holding it at a slightly tilted angle, apply the paste. Thus, one side of the lace is in greater relief than the other.

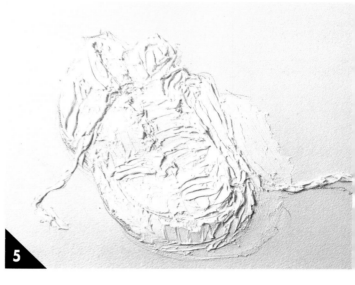

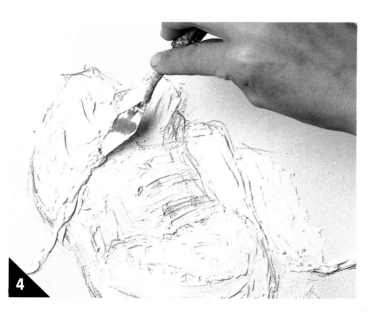

5 This is what the picture looks like after I have applied three layers of modeling paste. If you find it difficult to obtain a thickness of 1/8″ (3 mm), apply more layers.

6 Before the paste is completely dry, when it is still damp but does not stick or sag under pressure, you can work with various modeling tools. In the same way one would sculpt, I try to produce the most realistic expression of the sneaker with the acrylic paste. With a small amount of water you can even out the relief.

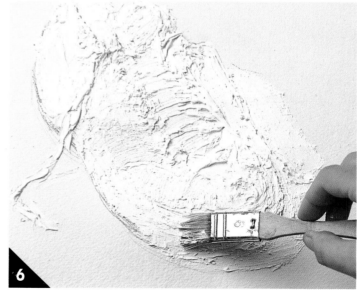

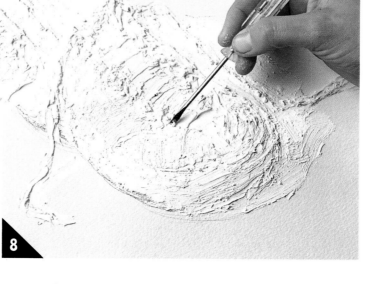

7 I smooth the edge with a cutter or scratch it with the tip. I can scrape with precision and make the edge of the lace stand out.

8 With the flat side of the screwdriver I remove paste to make the holes for the laces and work on the instep.

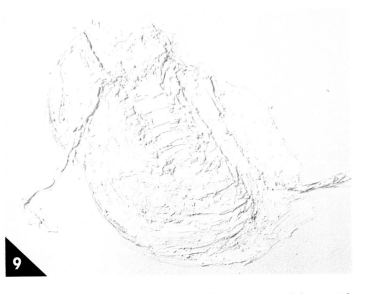

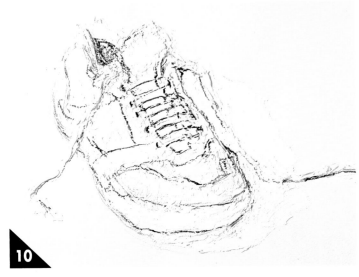

9 This is the sneaker after finishing the modeling with acrylic paste. I have developed the correct thickness of the laces, the tongue, the toe, and the back part of the shoe.

10 I draw the sneaker and its laces with a Conté stick. I choose this because it adheres well, blackens more, and mixes well with pastels.

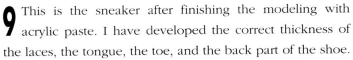

11 Now I take my hard pastels: a sienna, a dark gray, and a pale gray. I paint sienna and dark gray in the dark zones—the inside of the shoe, its shadows, and the ones between the laces. I reserve the pale gray for the lighted areas. Now you can see how little paint is really needed.

12 With the square-shaped number 6 brush, I am going to blend the pastels. I work on the areas I want to keep bright, rubbing with the brush from dark to light.

USING THE CUTTER

The cutter is a very practical instrument and highly recommended for many techniques. Try it out in different ways to find its full potential. I use the cutter for two processes with the acrylic modeling clay: first for modeling wet paste, and then for scraping and scratching the paste once it is dry. The cutter enables one to change or correct the lines of the drawing by outlining in white.

13 I restate the outlines with Conté pencil, or black or dark gray pastels. The tongue appears to project from the paper. If you want to open up white areas in the pastel, use the soft eraser (on the toe of the sneaker, for instance, where there is more light).

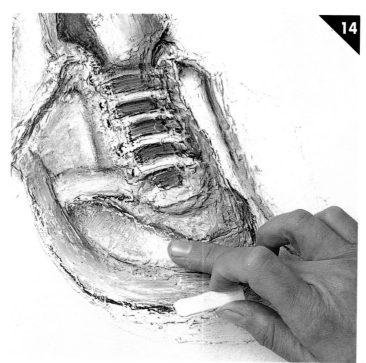

14 I lighten the general value of the shoe with white pastel. At this stage I decide on the intensity of the light areas. I notice a drawing error that needs to be corrected with pastels and the cutter.

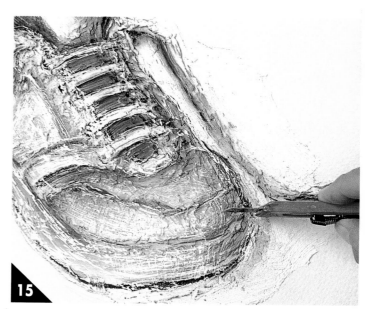

15 With the cutter, I incise white grooves in the paste. This sgraffito technique has a double effect—on the one hand it opens up white areas, and on the other hand, it emphasizes the roundness or volume (note the direction of the grooves). Sgraffito should only be used for illuminating (the laces, the toe, etc.) or for correcting the drawing.

16 I use acrylics to paint the shadow cast by the sneaker. A touch of black, some blue, and a lot of water provide me with the color of the shadow. Note the result—the texture of the acrylic paste is visible and there is a difference between the strokes that depict the tile and those of the sneaker.

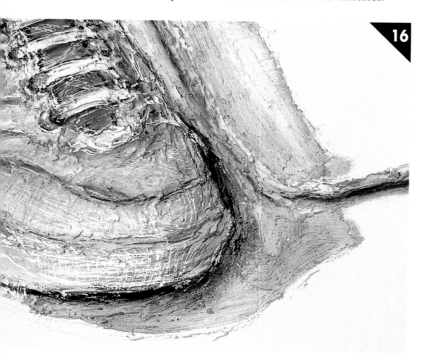

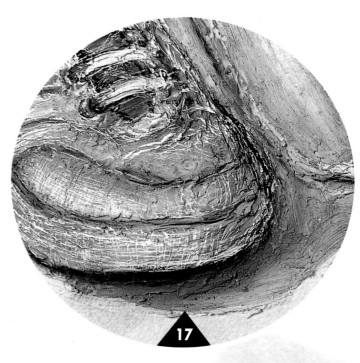

17 I reinforce the shadow below the shoe with sienna and dark gray using a clean, dry number 6 brush. The aim here is to create sufficient depth.

18 The pastels may have dirtied the paper. I run a rubber eraser over the entire surface around the shoe and its shadow. Now it's time to prepare for the final wash—adding color to the paper.

19 Step back and look at your picture for a minute. You may discover, as I have, that the picture needs more contrast. Now is a good time to add it. I dip my number 2 brush into some diluted black acrylic paint and outline the sneaker in order to definitively separate it from the background paper.

20 I want a honey tone, to emphasize the yellow lighting. I prepare large amounts of dilute mixtures of yellow and red (remember the surface to be painted is large). Using a flat brush, I paint the soft gradation by varying the proportion of water. I observe the lighting; the paint will be darker toward the top as well as down the entire left side of the sneaker. Read step 22 before continuing.

21 I lighten the wash where it is necessary, using blotting paper. I also lighten the shadow with a brush-stroke of the same mixture.

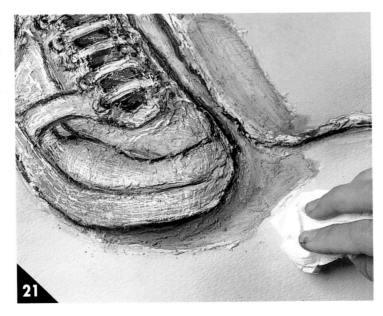

TONING THE PAPER

Why tone the paper? In this case, it is done for contrast. Because the white of the acrylic paste is different from the white of the paper, many details of the acrylic modeling paste relief don't show up due to the similarity in color. These can be seen more clearly when contrasted with another color. When the color is ready, prepare the paper. With a clean palette and water, wet the entire surface of the paper in order to prevent stains from forming.

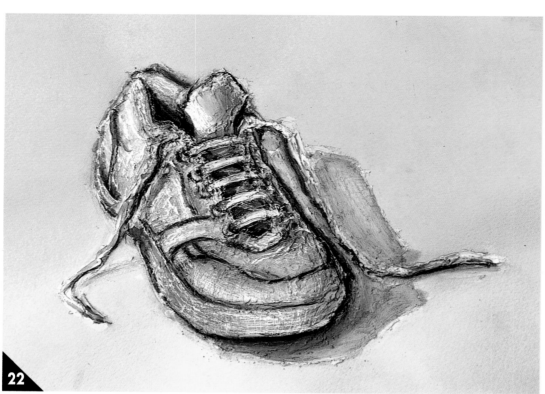

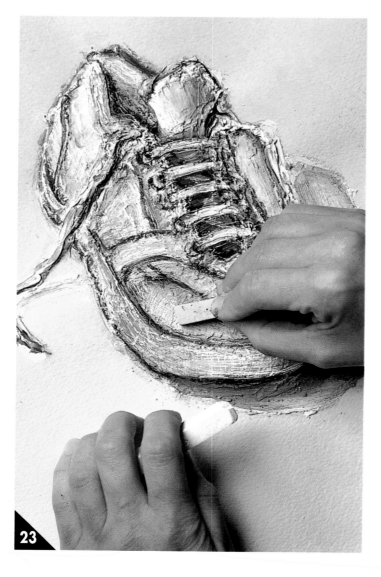

22 See how the honey color lightens as it dries. It is useful to do a test run on a separate piece of paper beforehand.

23 With ochre and white pastels, I lighten the sneaker. There is no need to go over the entire shoe, only the highlighted areas, such as the toe.

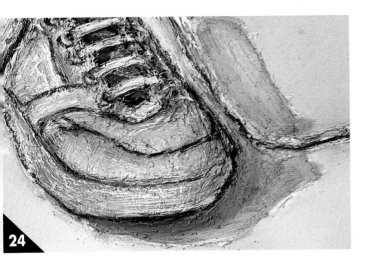

24 The paper is drying. I can still accentuate the change of texture between the paper and the acrylic modeling paste. Therefore, with the number 2 brush and some of the honey color, I outline the area where the paste stops.

25 In the area I just finished painting, I apply the first wash. Thanks to the contrast in value, the paste stands out even more. Using the same color, I paint the light behind the sneaker and thereby highlight the left lace. As we have seen, this mixed technique is easy to use. We have achieved an interesting result from a relatively easy exercise.

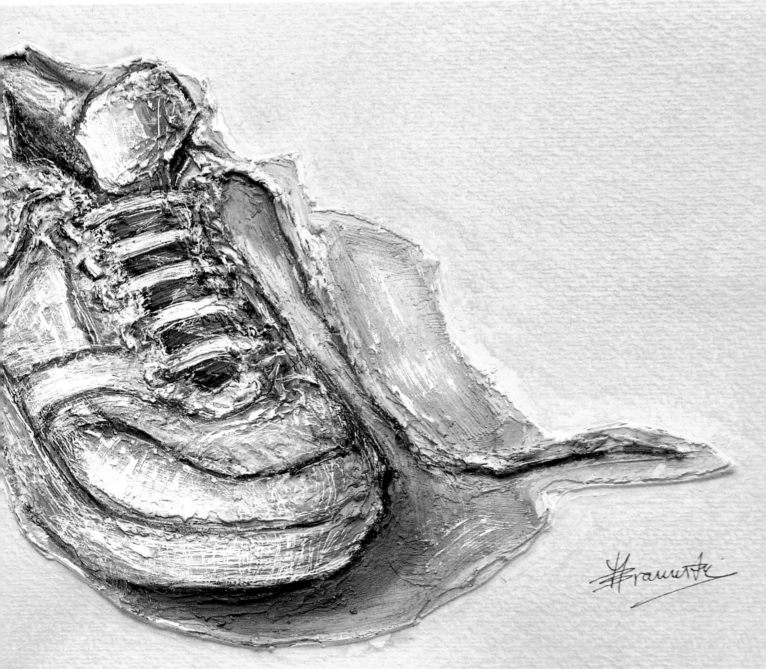

PASTELS AND GOUACHE

Pastel is a medium frequently used for painting portraits because it is ideal for coloring and drawing at the same time. For blocking in the picture, the sketch is usually begun in charcoal, Conté crayon, or chalk. Then pastels are used to give depth and volume to the painting.

I normally work with soft pastels and square-shaped pastels. The hardness of the latter allows me to lay in energetic lines with character. I use soft pastels (the round ones), which wear down very quickly, on the background. Pastel pencils are hard, making them handy for drawing fine lines. The pastel medium is virtually unrivaled in freshness and color. What would be the result of painting some gouache on top? Certainly the picture loses some of its freshness, but the work appears less fragile. Even when fixed, pastel comes unstuck from the paper, which would not happen if you apply gouache on top. However, what I really find interesting about combining these two media is that one can create thick impastos; in other words, the color can be applied in different densities and thicknesses. I can even repeat the same technique several times in the same place—a layer of pastel, another of gouache, and so on, successively. In this way different textures can be developed.

The prime interest in this exercise lies in:
• making the line or stroke an essential element in a good drawing (pastel);
• learning to master precise, fine brushstrokes (gouache);
• learning how to evaluate values;
• learning about the use of cool and warm colors;
• understanding the most important aspect of expression.

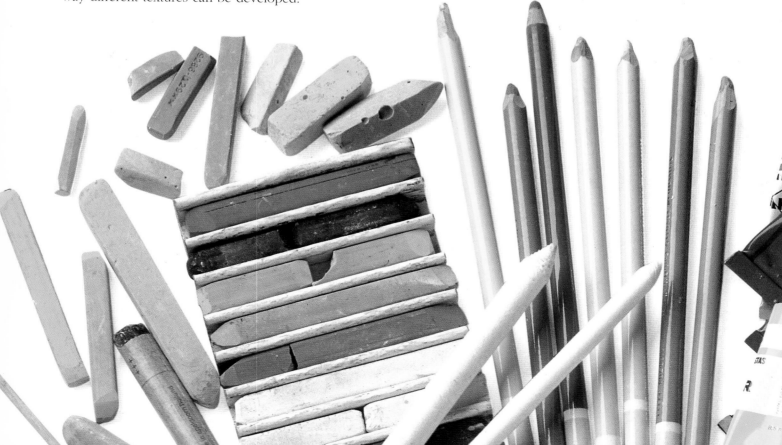

C

WHY PAINT A DOG?

I suggest painting a dog for the following reasons:
• Because its coat provides us with the chance to use multiple strokes, both soft and hard. (We will put off the question of painting the texture and color for another occasion.)
• Because the expression of a dog is easier to capture than that of a human; therefore, it is a much less complex subject to paint.

Let's examine some of the particularities of the materials with which we are going to work. You can apply color using the tip, corner, edge, or entire length of the pastel stick. You will thus create strokes of different thicknesses (A). Note the possibilities of drawing fine strokes (B); they can be so fine that they are gradually lost in the paper or they can be intensified.

Pastels can be blended, which in plastic terms is one of this medium's most interesting characteristics. You can use your fingertip, a cotton cloth, or a stomp to create dramatic chiaroscuros. In addition, you can obtain graded color areas that change in intensity or value, using the same tools (C). Gradations constantly crop up when painting pictures in pastel.

Pastel can be mixed optically or by superimposing light colors over dark and dark colors over light, as you are about to see in this exercise. We have provided you with a few mixtures that you should find useful: unblended colors around the edge, blended color in the center (D). You will end up, of course, with your own personal palette. It is enough, however, to have a light, a dark, and a medium value of each color you use. Starting off with too many pastels can create confusion.

By using gouache from the tube and two brushes, the preparation of the colors I will use for this exercise do not pose any particular problems. A thick brush is loaded with white, then a small amount of another color is added (yellow, for instance) with a number 00 brush. Next, a brush loaded with a little water is used to mix everything together into a smooth mixture that, in this case, would be a yellowish white. Remember to clean your brush with clean water each time you change colors.

A white porcelain dish is ideal for mixing paint.

See in figure (E) the example of pastel; below, strokes of gouache are applied on top of pastel.

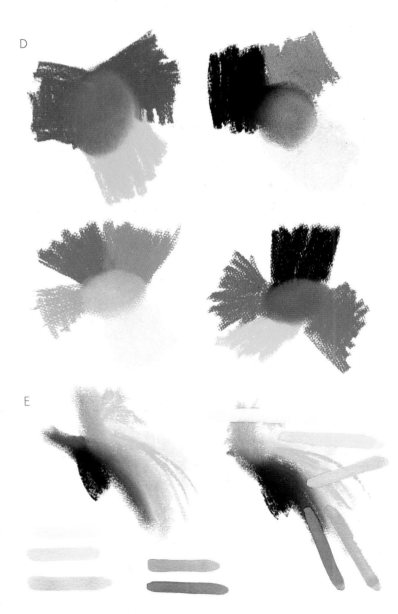

D

E

A DOG

I *begin by sketching the dog in charcoal. Then I can proceed with sanguine and pastels. This provides me with a firm base from which I can begin to apply the brighter tones. From then on, the work of painting gouache on top begins. Be sure that you attach the paper to a board on an easel. Before you apply the first lines of your sketch, observe the dog closely. Think how you are going to center its head and locate the most intense zones of light and shadows. You are going to learn a lot during this exercise. Now, let's get to work.*

1 With a stick of charcoal, I draw very lightly, to block in the head. I carefully make the suggestion of the eye that cannot be seen and draw the other eye. The foreshortened eyes give a good sensation of volume. These faint lines can be easily corrected. To change them, I blow over the area, then gently run a cotton cloth over it to erase the error. If anything still remains after this, use a rubber eraser.

MATERIALS

- Pastel paper, ochre color, 16" × 20" (40 × 50 cm).
- Sticks of charcoal and sanguine Conté crayons.
- Medium-size stomp, pencil, cotton cloth, and soft rubber eraser.
- Pastel sticks: black, dark gray, sienna, and white, in cylindrical sticks (Rembrandt*); orange (two tones), pale purple, pink, pale violet, pale gray, and white, in square-shaped sticks, (Eberhard Faber).
- Pastel pencils: white, yellowish white, purple, pink, white (one darker, closer to carmine), grayish white, and black.
- Gouache: white, yellow, yellow ochre, carmine, burnt umber, ultramarine blue, and violet.
- Brushes: a 00 for watercolor or gouache, and a number 2 or number 4 square brush.

The shadow of the highlighted tufts of hair, although light, have a cool hue (violet, blue).

With a fine line of gouache, I paint a hair that unexpectedly crosses the eye. Details like this lend realism to the work. One good detail is worth more than too many details.

Deep contrasts between light and shadow can be found in the eye, the nose, the mouth, and the chin. The dark mixtures are obtained from black, dark gray, sienna, and sanguine.

The tongue should be treated by soft blending, while the hair requires a multitude of strokes.

I only use the gouache in the most illuminated areas, such as under the chin and mouth, to separate the head from the paper. I use warm whites (with yellow, ochre, sienna, and sanguine).

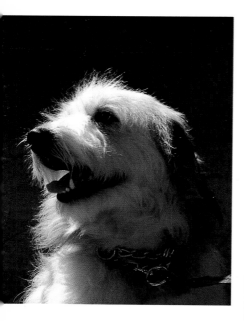

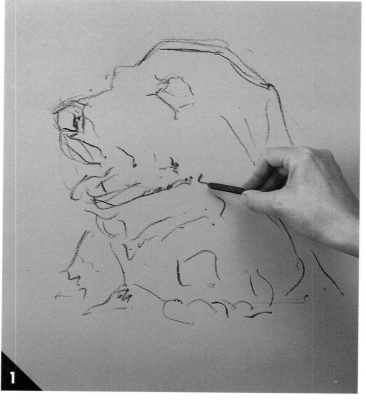

THE STROKES

Brushstrokes should give character, personality, and meaning to any picture. If you get used to painting very free brushstrokes, your work will gradually acquire rhythm. It is always important to spend time learning this technique.

*There are several good brands: Holbein, Sennelier, Rowney, Schminke, Grumbacher, Talens van Gogh, Weber.

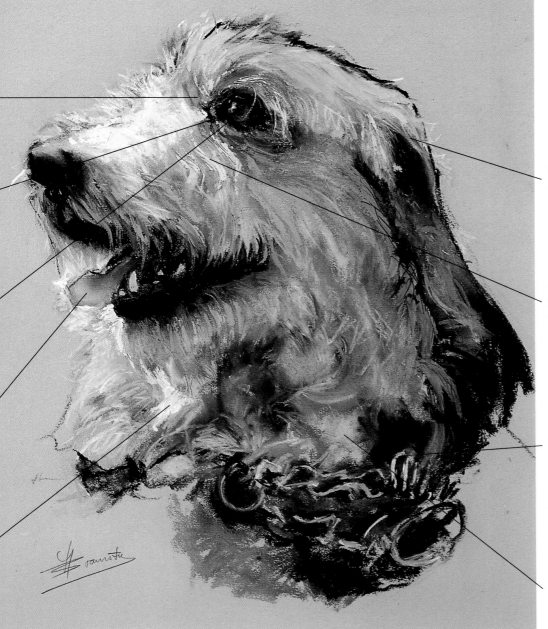

The ear is very lightly defined. I concentrate on the hair above it.

The lightest areas have been painted with pastel and gouache.

The chain is not an important element in the composition. I suggest it with dark strokes, contrasting them with others painted in light gray.

In some places I leave the paper clean and unpainted. I deliberately chose this color paper in order to harmonize it with the general colors of the dog and produce a soft contrast.

2 Do you remember that I recommended that you establish the light and dark areas? This is going to be very useful now. I apply the strokes in all directions to express the movement and fall of the hair, as well as the lighting on the face. In this way I obtain rhythm. I paint the nose, eye, mouth, and neck. It is essential to keep the lightest zones clean. Make the dark strokes strong. If you don't do it this way, the work will lack contrast.

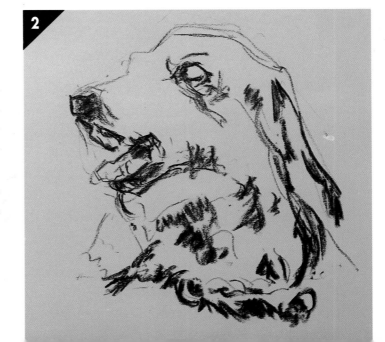

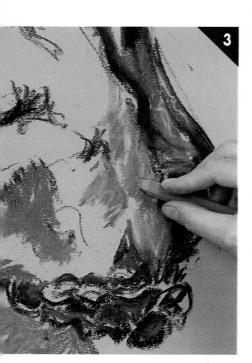

3 Sienna and dark gray. Note the strokes of pure color and the areas where the colors are blended by superimposing successive layers. I reinforce the charcoal outlines with black pastel. There is no need to go over everything except to heighten the tones where necessary in order to enrich the picture.

4 I continue painting with the same colors. I begin working on the dog's expression. I study the eye and the eyebrow. I mix some sienna and dark gray for the eye itself, and blend it with a circular movement. The eyebrow adds expression to the face.

5 Pink, sanguine, and white. I develop the roundness of the neck and the ear with sanguine colored Conté. The teeth are outlined in black. The tongue requires special treatment. For the time being I leave it as it is. I paint the light areas with pink and white, darkening with sienna and sanguine. I use my finger to blend color on the tongue, working from the lightest part to the darkest. By blending color this way, I avoid soiling the light areas of the painting. I continue defining the mouth and the neck. I add details to the chain. Last, the lower eyelid is painted with dark sienna.

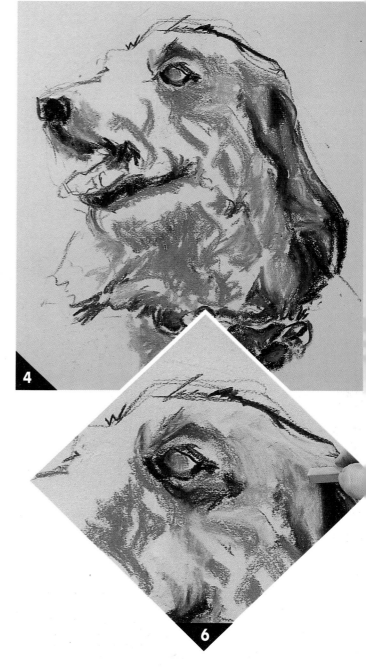

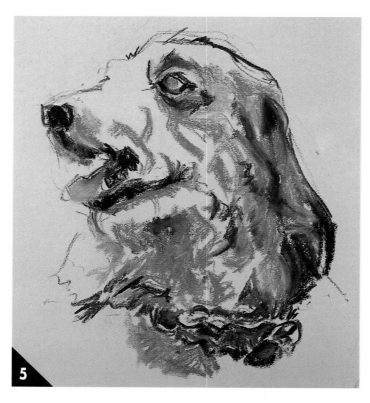

6 With fine strokes of pale gray and pale violet, I paint the surface of the coat. On the head, just above the ear, I begin working on the highlighted areas of the coat with pink and white.

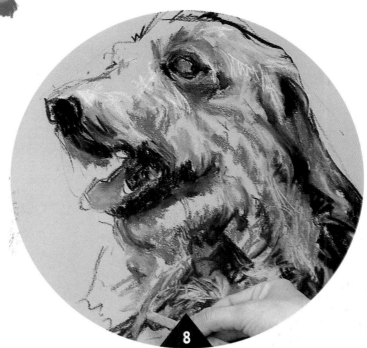

7 This is the way the drawing now appears. I refine the drawing beneath the nose with several black strokes. At this stage, I am using white, pale gray, and pink. Remember, the strokes should follow a consistent pattern, by either focusing on the direction of the hair, the movement of the dog's hair, or on the direction of the light source. I continue to block in the chain with sienna and sanguine Conté.

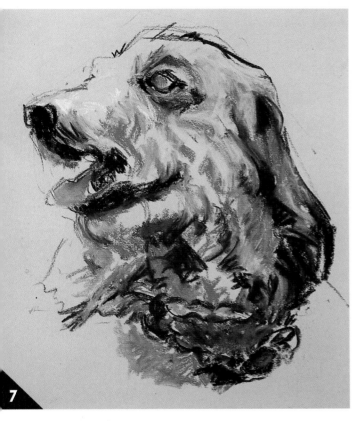

8 This is the step that reflects the dog's expression. With a few strokes of sanguine, pale gray, and sienna, I manage to capture the movement of the eye. I continue outlining the mouth with black, indicating the tips of some hairs. I paint with sanguine beneath the nose and on the lower jaw. I continue using pale violet for the details, superimposing strokes with which I balance the intensity of the light.

9 Here you can see the work on the chain. I use pale gray, black, and white. I chose only the most significant aspects of the chain so as not to make it stand out too much within the composition. Observe the contrast; a few lines that combine pale gray, with a touch of white highlights make them appear to stand out from the surface of the paper.

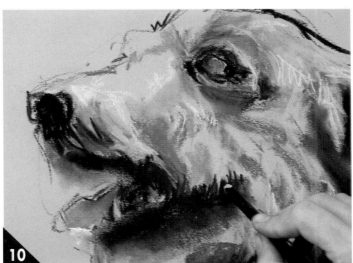

10 I outline some tufts of hair in areas of greatest contrast, using black pastel. This close-up allows one to see in greater detail some of the blended areas: inside the ear, below the eye, beneath the nose, and under the lower jaw. These blended areas add to the three-dimensional appearance of the dog. It is not possible to give equal importance to everything. However, it is essential to make the foreground stand out; therefore, some details are lost when they are blended, and, by contrast, others are more accentuated.

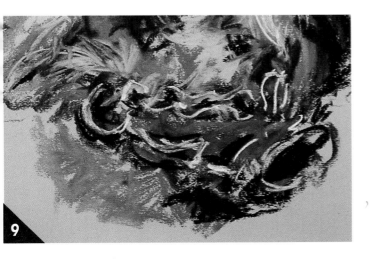

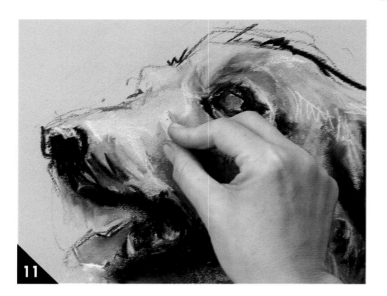

12 To capture the expression of the eyes, place the pupil between the eyelids. If it is done correctly, the fore-shortening of the eye will be successfully executed, as well as the direction in which the dog is looking. I mix sienna and charcoal, blending softly with my finger in circular movements. Then, with the stomp, I remove some color, to indicate the lightest part of the pupil. Last, I add the catchlight on the eye with pale gray.

11 Now I begin to work in greater details as I add light colors. With pale pink and white I paint around the mouth and the nose. Where it is necessary, I add tones of pale orange, which I then blend. I also paint the top of the head. In addition, I add a pale gray highlight on the nose.

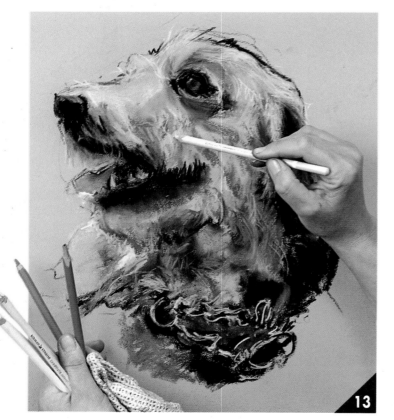

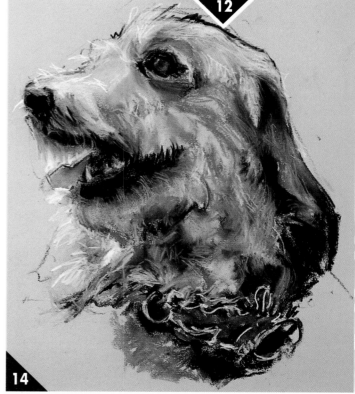

13 I add strong orange touches to the lower jaw. I continue defining the head with pencils in white, yellowish white, pale purple pink, one with a carmine tendency, and a grayish white one for the cool hues. Note the lighting, and always consider the tonal values.

14 I study the different color strokes. The head has acquired form and volume. Allow me to repeat—the hair is not all the same color nor does it receive the same light; if you paint the entire coat in a uniform color, it will not produce a three-dimensional effect.

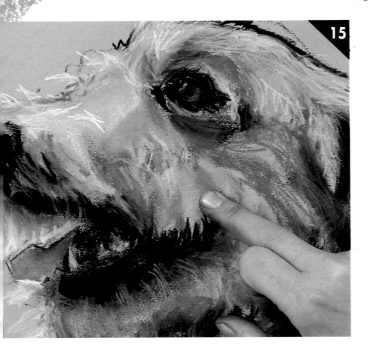

15 I am indicating the area of blended colors and the contrast of the nearby black and orange lines. Note again—a three-dimensional appearance is produced by a good drawing and correctly applied colors, as long as the strokes accentuate the form in question. If they do not, the result will be a poor work lacking rhythm. Don't worry—it is not a question of inventing, but of judging, so blend colors when you decide it is necessary, even if you erase a detail that appears good but is out of place.

16 I continue to lighten the work with pencils, using the white, the yellowish white, and the pinkish white ones. I try to give each area enough attention so as to balance the light of the work as a whole. I use a range of colors. Try to express the rough hair on the left.

SIMPLIFYING AND HARMONIZING

A painter simplifies and harmonizes the subject matter. Simplifying means capturing the most important elements of a composition with a few strokes. I harmonize the whole by adding details needed to enhance the work.

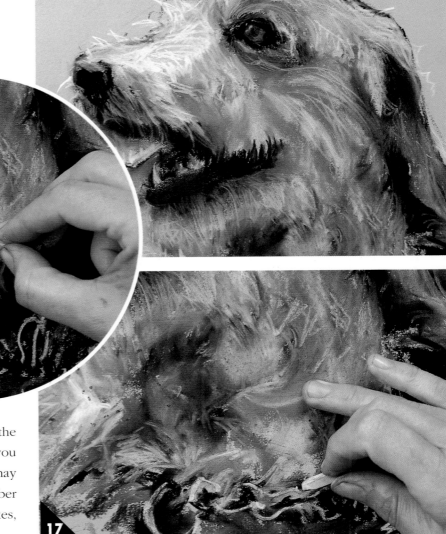

17 Remember, white seen in full light can appear yellowish or pink (a warm white), whereas in backlighting or in shadows, it will be a cool white with tones of blue or violet. This cool white that I apply over the dark background stands out too much; therefore, I must blend it in order to achieve the appropriate degree of contrast. I outline in black. If you understand why, you are learning fast, even though you may not yet know how to apply it. Don't worry—just remember that practice makes perfect. You will learn by your mistakes, but with observation you will certainly improve.

18 I start to mix the gouache. I'll use a fine number 00 brush for the details and a thicker one, using the thin or flat side, for the rest. I prepare intermixes of white with varying touches of carmine, yellow ochre, and yellow. This is my palette for the areas in full light. Next, I mix colors for the lighter shadows by adding blue, violet, and burnt umber to white. The catchlight on the dog's eye is painted in two delicate brushstrokes.

19 I paint a stroke of cool violet white on the nose; then I use my finger to draw the nose and the large highlighted area before it dries. I pay close attention to the contrast between the warm pale tones at the corner of the eye and the cool tones seen in the shadow beneath some tufts of dog hair. I am not speaking of going over everything in gouache. Beware—it is not always easy to know when to stop. If you have difficulty painting with gouache, check it by fixing a small portion of the drawing (with a fixative spray).

20 This enlargement reveals the differences in quality and nuance that exist between the blended areas, pure strokes, and brushstrokes. With the eye and the eyebrow complete, the dog has a real expression. Note the fine brushstroke.

21 Using a finely pointed stomp, I lift off wet gouache to make grooves in the paint. In this case, a cutter would be too harsh a tool. I leave dark strokes where I scratch off the light color. I am pleased with the effects of contrast obtained around the eye.

22 Last, we want to be sure that the composition has been harmonized and that form and volume are correct. In general, the result seems fine. I like the hues. I make sure the sprinkling of whites of the clean, unpainted paper enrich the composition. There was no need to apply thick impastos, but if you have to correct or change anything, you can do it by painting over the gouache with pastels, by blending, or by applying a new layer of gouache.

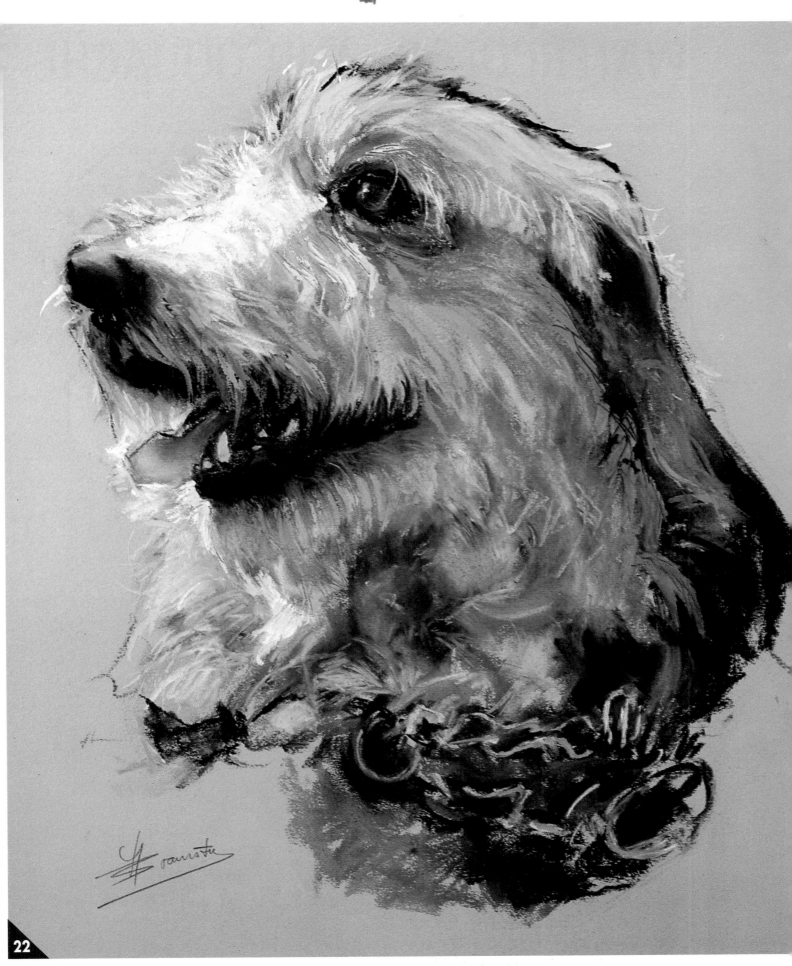

WAX CRAYONS, WATERCOLOR, AND GOUACHE

This is a simple exercise. You will need the following materials: wax crayons, watercolors, gouache, brushes, and a sheet of rough-textured paper.

The wax crayons are of the solid cylindrical type. The watercolors used are the square type that come in pans. Naturally, you will also need water to use them with.

A

The method used in this picture entails coloring the surface of the paper in wax crayon without pressing down too hard. The correct pressure leaves color only on the raised areas of the paper surface, while the hollows below remain white (A).

The second stage consists of applying watercolor on top of the wax crayon. What will be the result? The watercolor will settle in the hollows where the paper remains white (B).

B

The result of mixing both media, wax crayon and watercolor, with a brush on rough paper creates a pointillist effect, in which the colors are intensified by the contrast of value and color.

The result of painting gouache on crayons is very different. Gouache is thicker than watercolor. Check for yourself; see how it flows from the tube. It can be thinned with water just like watercolors. Gouache is characterized by its opaqueness, unlike the transparent quality of watercolor. What happens when you paint gouache on top of wax crayon and watercolor? It covers both wax crayon and watercolor. With brushstrokes of gouache, I break up the pointillist harmony of wax and watercolor on rough paper, since gouache strokes are opaque and flowing, in contrast to pointillism.

MASKING WITH WAX

Wax has a masking capacity. In other words, when it is applied on paper, it protects other colors. White wax is normally used for masking but this characteristic can also be obtained with other wax crayon colors. Wax colors reject watercolor when it has been diluted in a great deal of water.

CLARIFYING CERTAIN CONCEPTS

When we observe two colors side by side, an optical mixture occurs. By optical mixture we are referring to the juxtaposition of two or more colors. The optical mixtures that are included in this exercise have been chosen deliberately. With some knowledge of color theory you can decide on the most appropriate colors for creating the greatest color or tonal contrast

INTENSIFICATION OF COLORS

a) Two juxtaposed colors intensify each other by the difference in value: light value appears even lighter and a dark one appears darker still.

b) Two juxtaposed colors intensify each other by the difference in color: a color appears brighter if it is surrounded by a pale color, and vice versa.

When these contrasts occur, we speak of color intensification by value or by color.

I have looked for optical mixtures starting with the color of each object; therefore, I look for two colors. One of them is crayon (it can be a mixture of wax crayons), the other is watercolor (it can be a mixture of watercolors). The optical mixture of the crayon and the watercolor must provide me with the target color. In addition, I am interested in value and color contrasts between the wax color and the color of the watercolor I have chosen.

I am sure you feel like experimenting, so try to repeat some of these exercises. They are useful for understanding the process and are good techniques for use in *A Still Life with a Briefcase*.

An example of the colors used for the briefcase (C).

An example of the colors used for the wall and the newspapers (D).

Example of colors for the umbrella (with their different parts) and the table (E).

It's not difficult; just be observant. Find the wax colors and practice with the watercolor mixtures.

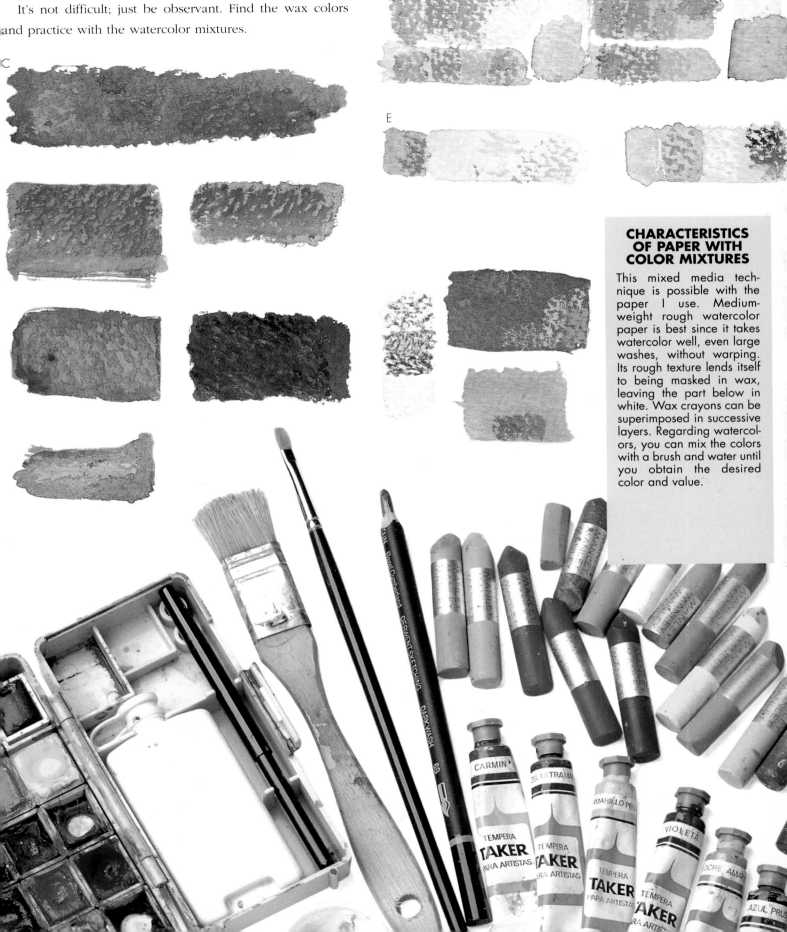

CHARACTERISTICS OF PAPER WITH COLOR MIXTURES

This mixed media technique is possible with the paper I use. Medium-weight rough watercolor paper is best since it takes watercolor well, even large washes, without warping. Its rough texture lends itself to being masked in wax, leaving the part below in white. Wax crayons can be superimposed in successive layers. Regarding watercolors, you can mix the colors with a brush and water until you obtain the desired color and value.

A STILL LIFE WITH A BRIEFCASE

With mixed media (wax crayon, watercolor, and gouache on rough paper), we are about to paint an attractive subject using a briefcase, several newspapers, a shelf, and an umbrella. After starting the sketch in pencil, we'll go on to paint with wax crayons. In the second phase (the most spectacular part of the work), we'll apply watercolor, which will add volume and color to the still life. Last, with gouache, we will paint flowing brushstrokes that will break up the pointillist effect of wax crayon and watercolor. So, let's get started—you'll see how the end result makes the effort worthwhile.

MATERIALS

- Rough watercolor paper 20" × 20" (50 × 50 cm)
- Water-soluble pencil.
- Flat synthetic brush ¾" (2 cm) minimum.
- Square number 4 brush.
- Pocket-sized watercolor set, with a number 2 brush: yellow, yellow ochre, purple, red, burnt sienna, burnt umber, ultramarine blue, Prussian blue, cerulean blue, and violet.
- Wax crayon colors: white, yellow, yellow ochre, pink, orange, carmine, purple, burnt sienna, burnt umber, dark blue, and violet.
- Gouache colors: white, yellow, yellow ochre, carmine, burnt umber, ultramarine blue, Prussian blue, and violet.

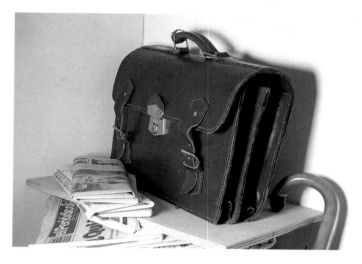

2 With a water-soluble drawing pencil, I sketch the entire composition, using a very light stroke. I try to keep the strokes loose in order to obtain the most artistic result.

An example of an optical mixture: the raised area of the rough paper is colored with a mixture of orange and carmine wax. Then I apply a watercolor wash, mixing yellow, red, and purple.

The near details are elaborated. The details farther away are mere suggestions. Everything in this composition has been planned to create an impact of depth and volume. I heighten it with this treatment.

I only use gouache on the metallic elements and some outlines. They are unbroken brushstrokes that act as a counterbalance to the pointillist harmony of the whole.

Note the reflections and highlights on the briefcase and umbrella.

Most of the warm colors are painted in the illuminated area, while the cool hues are reserved for the shaded areas. The warm colors consist of: yellow, orange, red, and purple (and their intermixes). The cool tones are: violet, blue, and green (and their intermixes).

The shadows contain cool and/ or dark colors, such as umber, violet, etc.

1 This is the sketch, done in charcoal on inexpensive paper. It is useful to block in the most important elements of the composition. I indicate light and dark areas, highlights, and reflections. The sketch should be lightly drawn without any details or contrast.

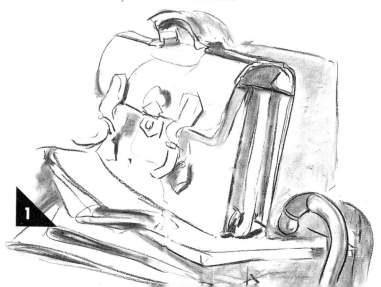

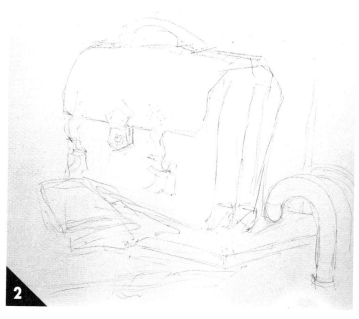

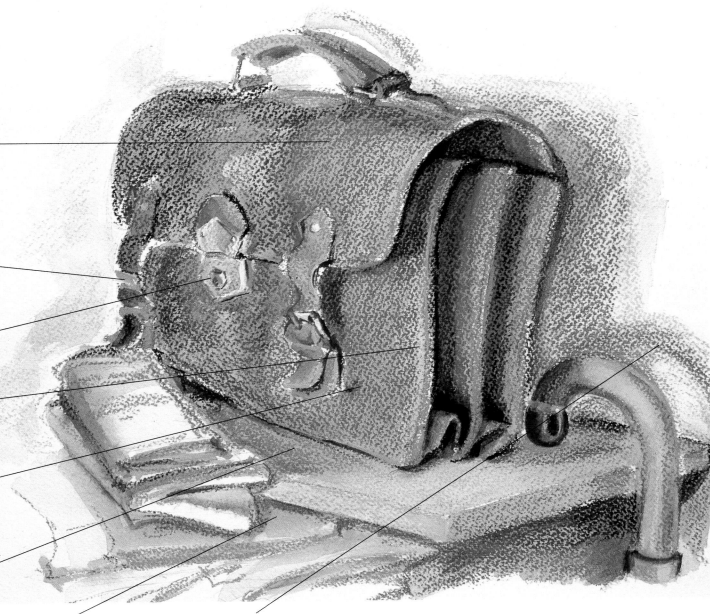

The wall to the right and left of the briefcase is painted with two washes, one on top of the other. In order to apply the second wash, you have to allow the first one to dry thoroughly. Remember to apply the dark wash over a light one. Note the work involved in the wall and the newspapers.

The shadows on the wall are not a uniform color, but contain hues that correspond to the proximity and nature of the objects that cast them. Study them carefully, just as you should with everything else.

3 With pale gray and dark gray wax crayons I indicate the shadow on the wall. Note that shadows are never uniform in color; learn to observe the hues and to understand what causes them. I now work on the newspapers, with a pink crayon. With a dark blue one, I sketch the limits of the shadows cast by the briefcase. I apply a touch of carmine and umber to the umbrella.

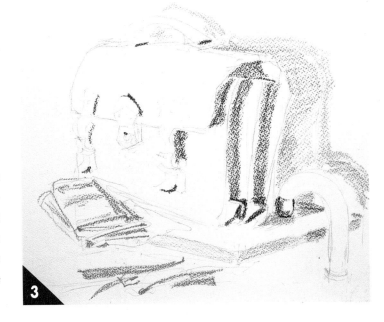

4 I paint carmine, purple, violet, and dark blue in the shadow beneath the table. I darken it toward the background. I color the briefcase with orange crayon. This color comes from applying carmine on top, in such a way that carmine and orange, blended together, produce the color of the briefcase where the light falls in its most illuminated part. For the clasp, I use a pale blue and a pale gray.

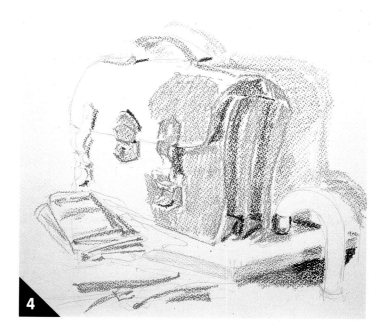

5 The shadow cast on the table by the newspapers is painted with sienna, pale gray, dark blue, and dark gray. The briefcase has areas of reflected light and highlights. I represent them with crayons: pink, carmine, pale blue, and pale ochre. Umber is used to block in the shadows, while the upper part of the shelf is painted with ochre and sienna.

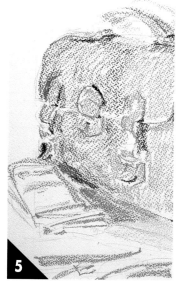

6 Now I work on the umbrella and the wall. I paint the umbrella with pale ochre, pink, carmine, sienna, and umber. I shade the wall with colors similar to those of the briefcase and the umbrella: ochre, pink, and sienna.

7 Now I superimpose wax colors on top of those I have already applied. I'll add contrast to the accordion pleats of the briefcase with violet. I apply carmine over orange. I darken the background of the briefcase with violet and sienna. I emphasize specific aspects of the drawing. The underside of the shelf is painted with dark gray and burnt sienna.

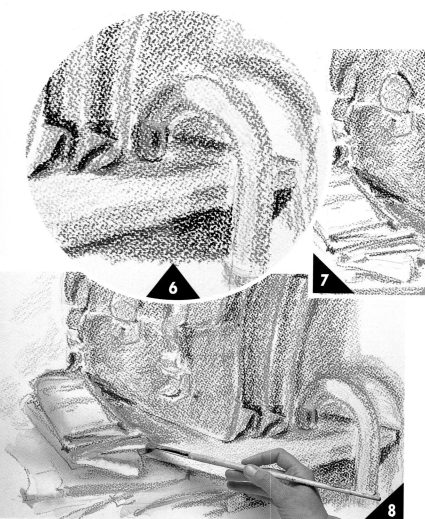

8 I start to paint the newspapers in watercolor. To modify the pink, I add yellow ochre, red, purple, and violet. With very diluted color and the flat brush I lay in a graded wash. The gray of the newspaper is painted with cerulean blue and umber.

MIXING WAX COLORS

There are several ways of mixing wax crayon colors. Here we use only combinations resulting from applying successive layers.

WATERCOLOR BRUSHES

Large areas are painted with flat wash brushes. For fine details I use a number 2 brush.

WASHES AND GRADED WASHES

To paint a watercolor wash, you can paint on dry paper or you can wet the paper in advance. You can vary the color and value by adding more water to the mixture; these are graded washes. In order to apply another wash over the first, it is essential to wait until the first wash is completely dry.

9 I repaint the shelf with very diluted yellow ochre. The crayon and watercolor give it the necessary depth.

10 I prepare two mixtures for the handle of the umbrella; the shadowed area is painted by mixing purple, sienna, and carmine, whereas the area in full light is painted with yellow ochre and sienna.

12 The briefcase is painted by mixing yellow, red, and purple. Where the briefcase appears darker, I'll add more purple, and where it is lighter, more red and yellow. The wall on the left has been painted with violet and very diluted cerulean blue. I use two layers of watercolor wash in two values.

11 The wall is painted with cerulean blue and umber. The color must be very diluted with a lot of water. Large areas must be covered with sweeping strokes. I paint the area below the shelf with the same colors but in a somewhat more bluish hue, and with slightly more color.

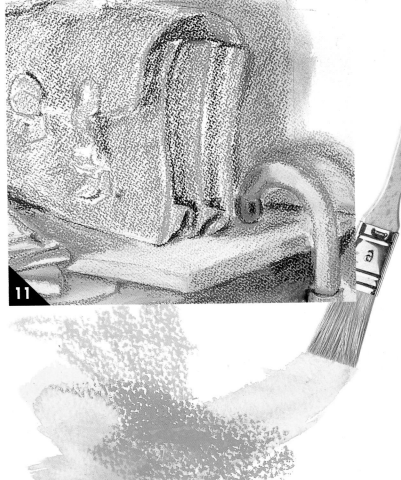

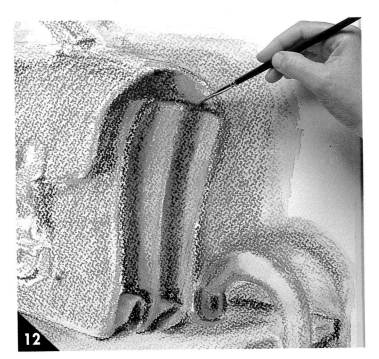

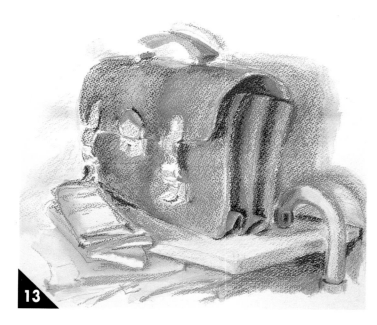

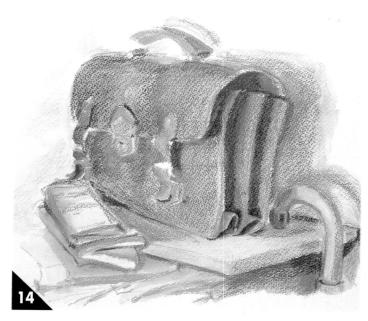

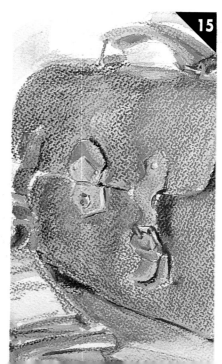

EVALUATING THE RESULT

Having reached this point, I suggest you step back and observe your picture. Now is the time to correct any mistakes you see. Wax can be removed, with the utmost care, using a cutter. Then that area can be colored again. In any case, don't abuse it, because the color will become dirty. Regarding watercolor, if you have followed our instructions and have tested the color on a separate piece of paper beforehand, you should not need to change it.

13 I continue working on the briefcase using the same mixtures: yellow, yellow ochre, red, and purple. For those areas where reflections acquire a greenish tone, a mixture of yellow, yellow ochre, and red is adequate. To the left of the briefcase, I start painting a violet-blue tone, using cerulean blue and violet.

14 I finish the briefcase by unifying the leather with a yellow-purple wash, which I paint around it to the left of the lock. The part of the strap in the background is darker than the other. Now, I move on to the shadow cast by the newspapers. I use the same mixtures of color as in step number 8, although much denser. In the newspapers, the shadows are obtained with cerulean blue and violet. I reinforce the contrasts with carmine and violet.

15 Working with gouache is simple. Mix the colors from the tube with some water and a fine brush, and try to keep it as close to the natural color as possible. I add more detail to the nearest objects and leave the more distant ones as faint sketches. I try to apply artistic strokes. On the metal parts I paint white, Prussian blue, and umber. For the darkest areas, I use carmine, umber, ultramarine blue, and violet. The strap and the tongue are painted with yellow and carmine (orange).

16 I add the final details. The highlights are applied with crayons: yellow, yellow ochre, and pale blue. I mix that special green for the top part of the briefcase and the handle. Can you see that bluish-violet detail? I correct the umbrella, adjusting the handle with dark crayons. The highlight on the handle can be done in two ways: by painting with white gouache or by scraping away the color with a cutter.

Well, there you have it. You may have found it complex at first. But as you have seen it really was extremely simple.

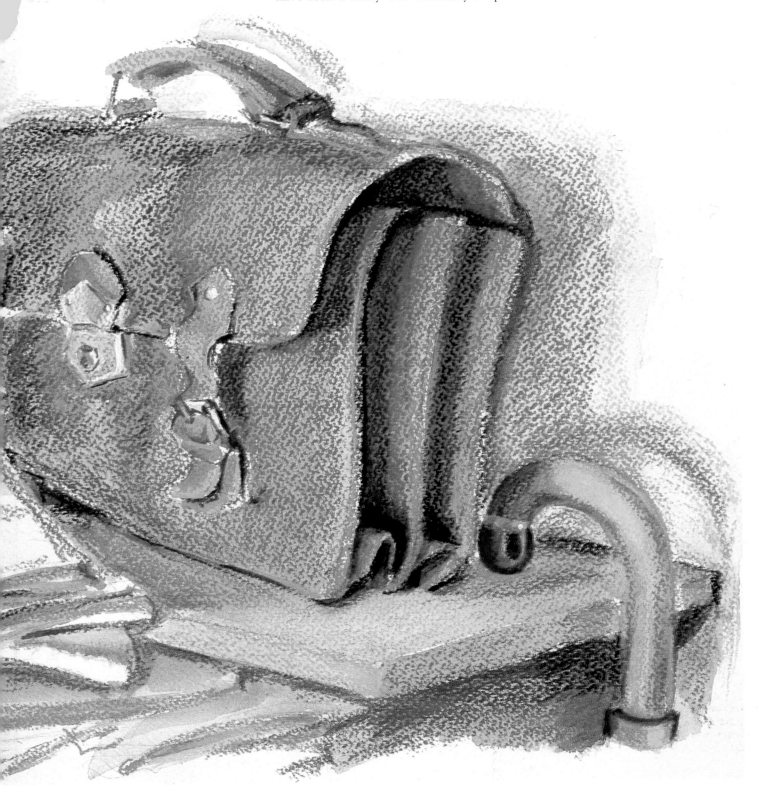

ACKNOWLEDGMENTS

I don't think I can thank Jordi Vigué, Editing Director of Parramón Ediciones, enough for giving me the opportunity to write this book. By doing so, he allowed me to convincingly demonstrate that the use of mixed media enriches the creative potential of any work. My thanks also to Josep Guasch, Jordi Martínez and José Carlos Escobar, for their work on the graphic design work and phototypesetting. Thanks also to Nos y Soto for their splendid photography (and their remarkable patience during the sessions); and to Vicenç Piera of Barcelona for his material and help. Once again, without the ideas, advice, constant help, and support provided by Jordi Vigué, this book would not be what it is.

Mercedes Braunstein